Marjorie Sarnat's
fanciful fashions

Racehorse Publishing books may be purchased in bulk at special discounts for sales promotion, corporate gifts, fund-raising, or educational purposes. Special editions can also be created to specifications. For details, contact the Special Sales Department, Skyhorse Publishing, 307 West 36th Street, 11th Floor, New York, NY 10018 or info@skyhorsepublishing.com.

Racehorse Publishing™ is a pending trademark of Skyhorse Publishing, Inc.®, a Delaware corporation.

Visit our website at www.skyhorsepublishing.com.

10 9 8 7 6 5 4

Cover design by Brian Peterson
Cover artwork by Marjorie Sarnat

Print ISBN: 978-1-5107-1256-0

Printed in China

Marjorie Sarnat's
fanciful fashions

New York Times Bestselling Artists' Adult Coloring Books

MARJORIE SARNAT

Racehorse Publishing

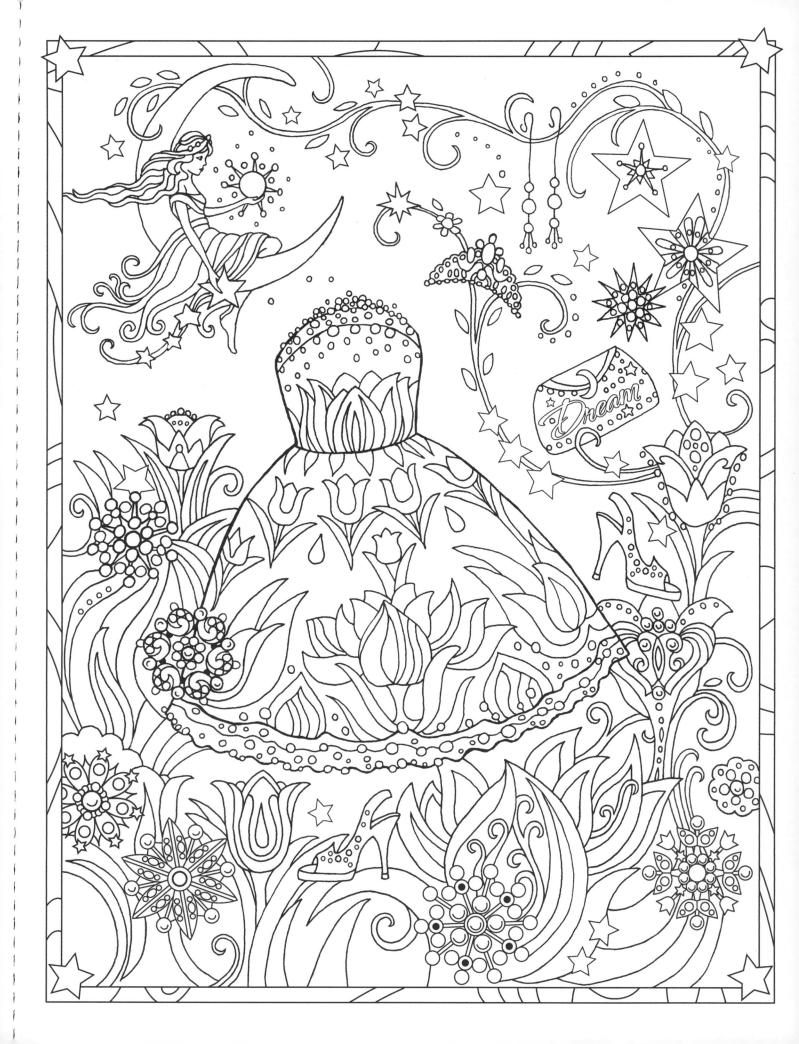

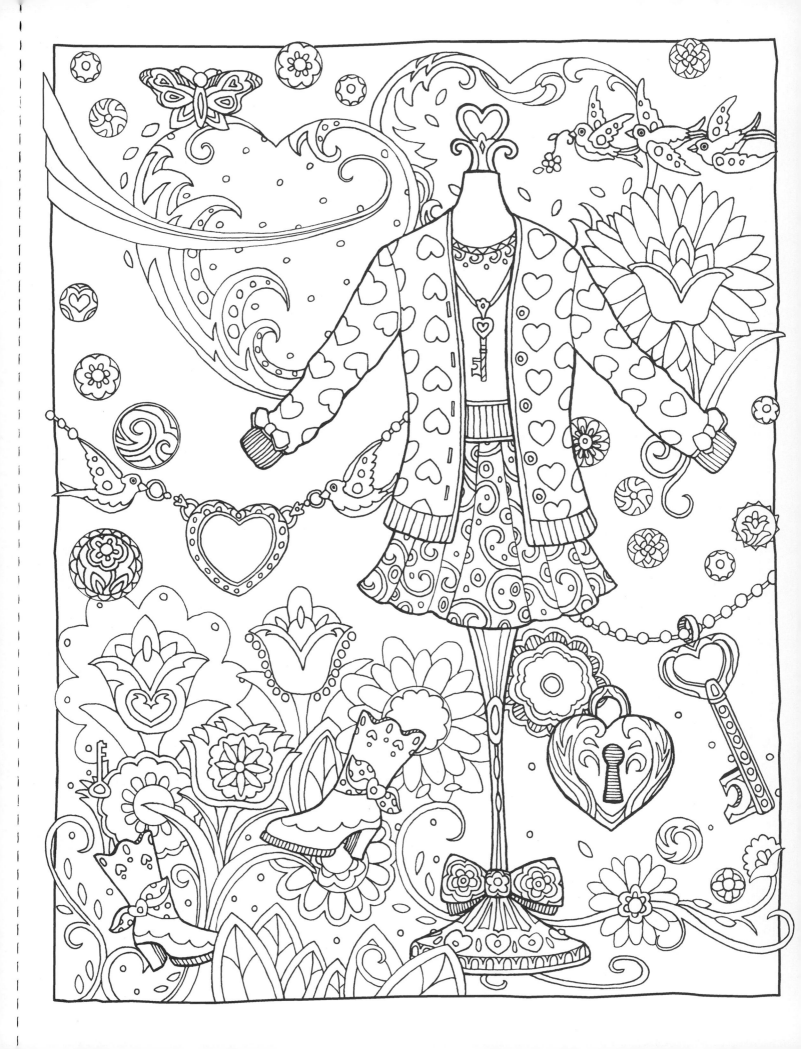

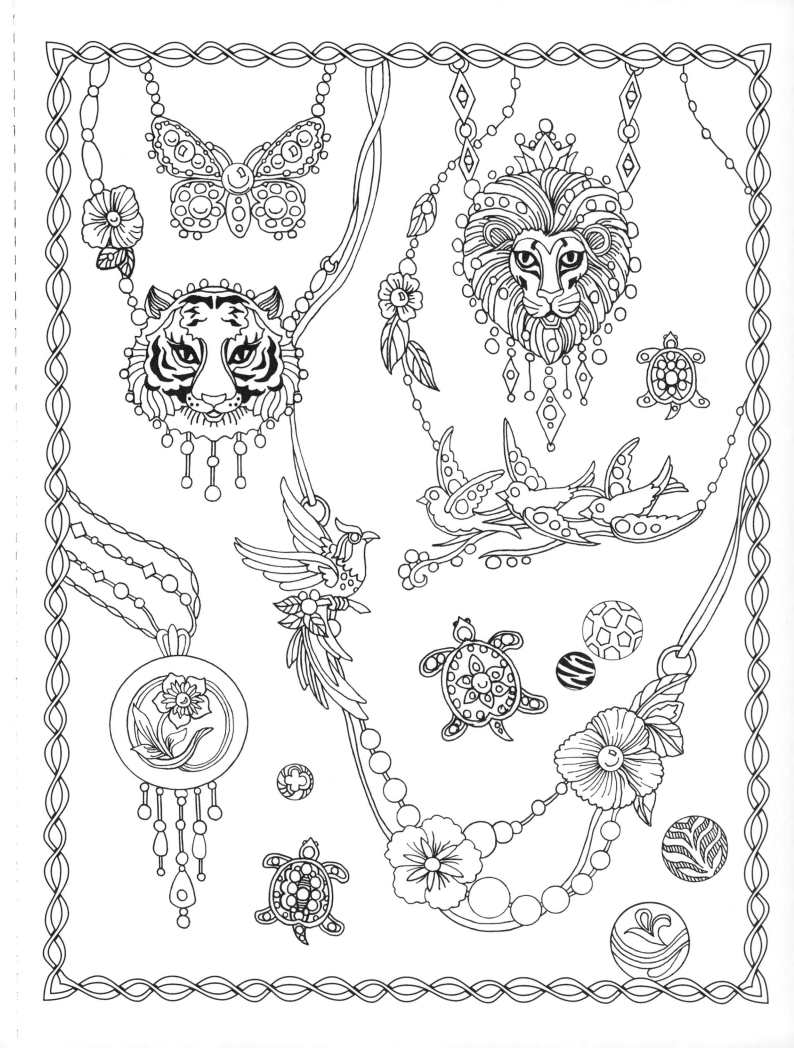

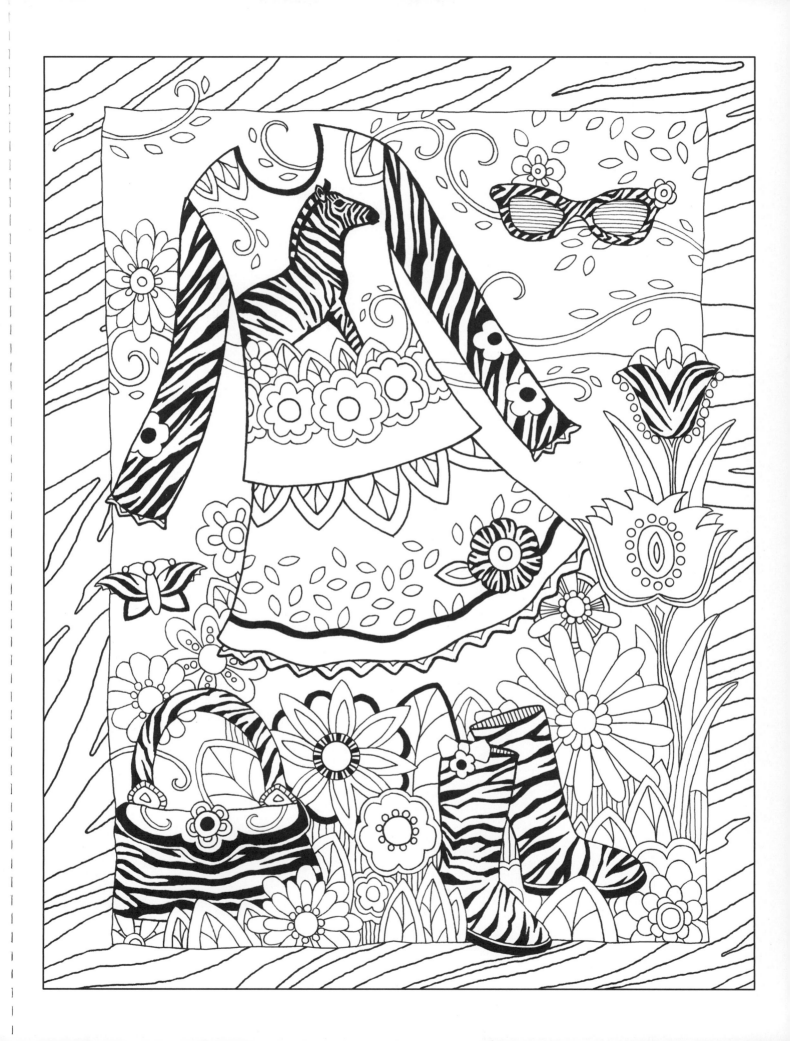

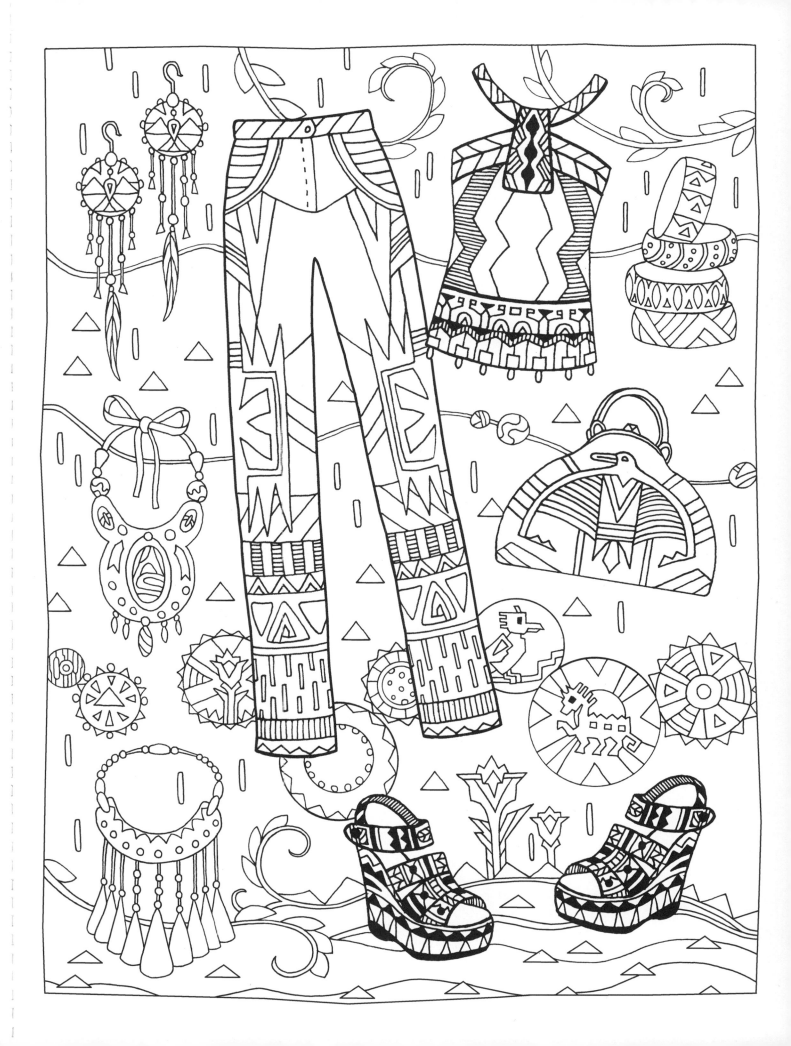

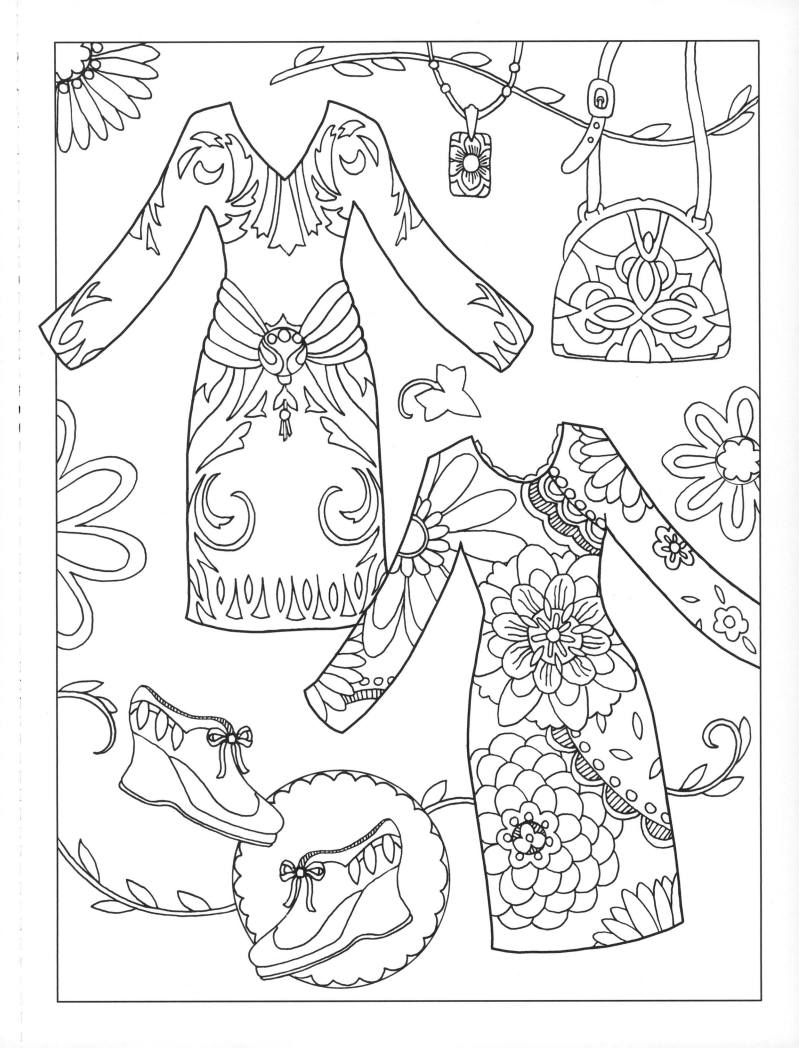

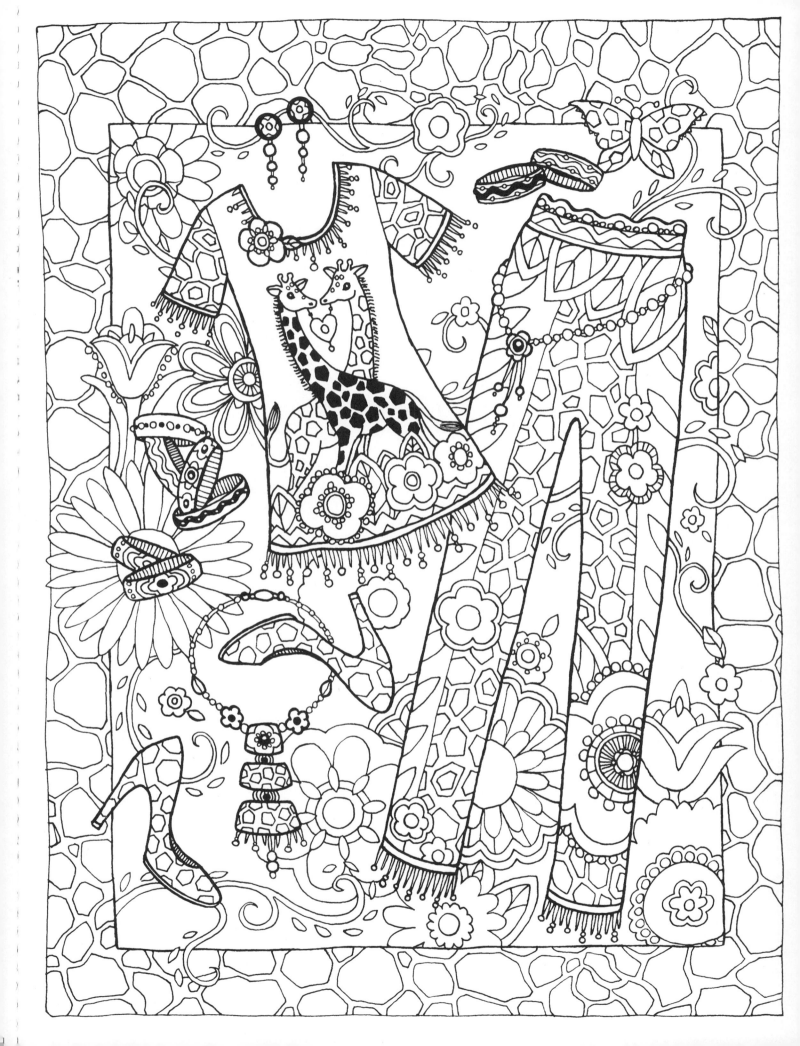

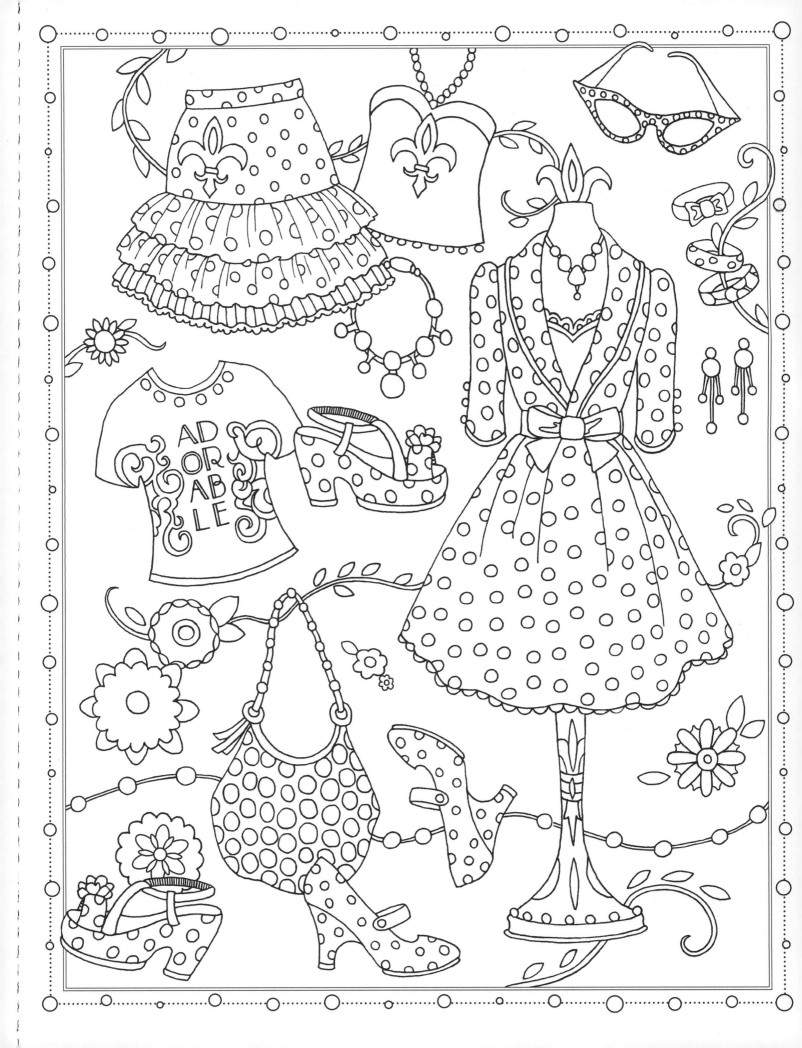

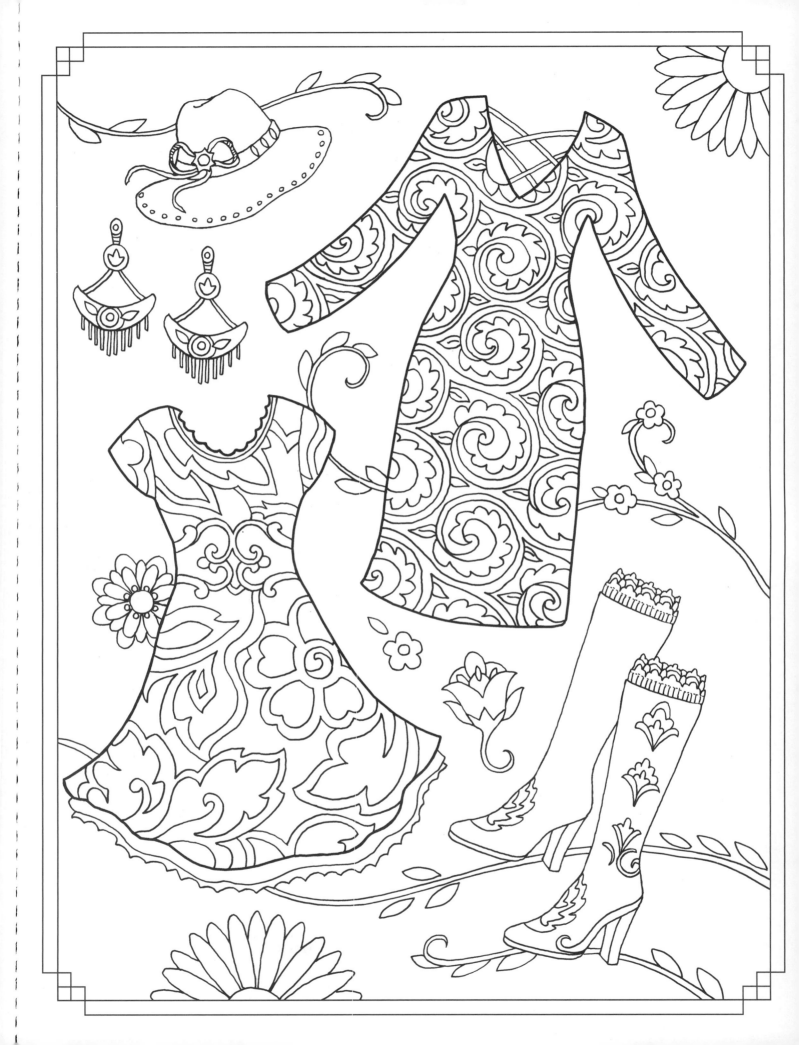

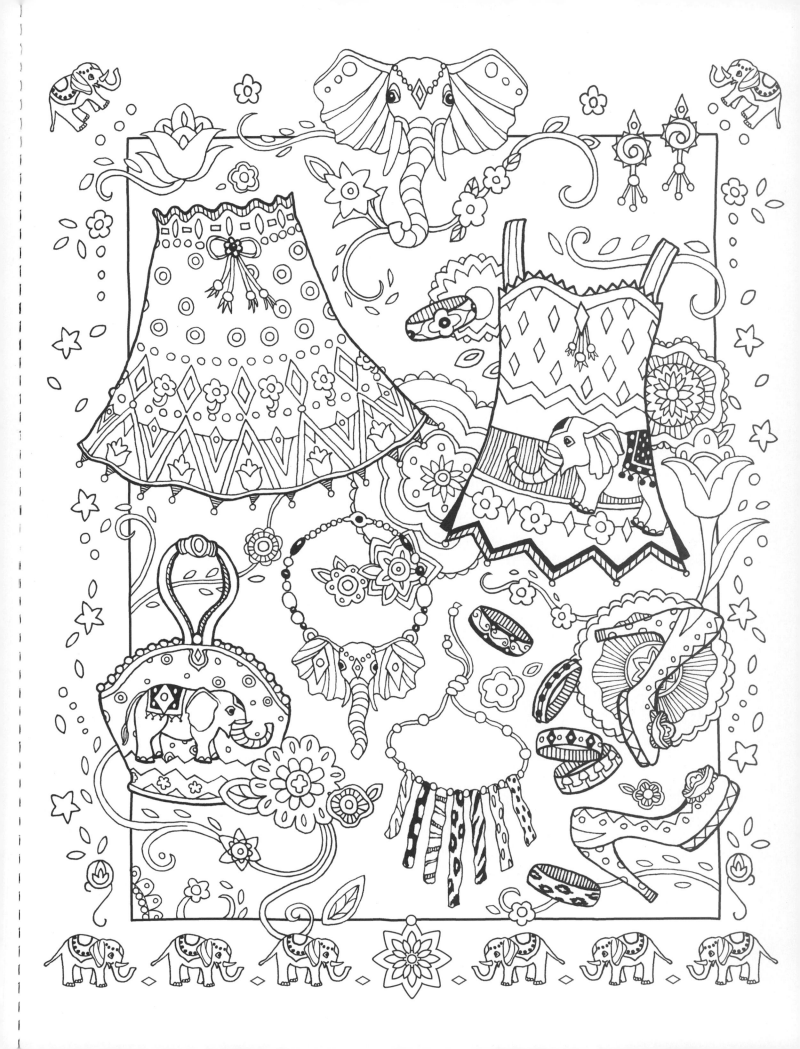

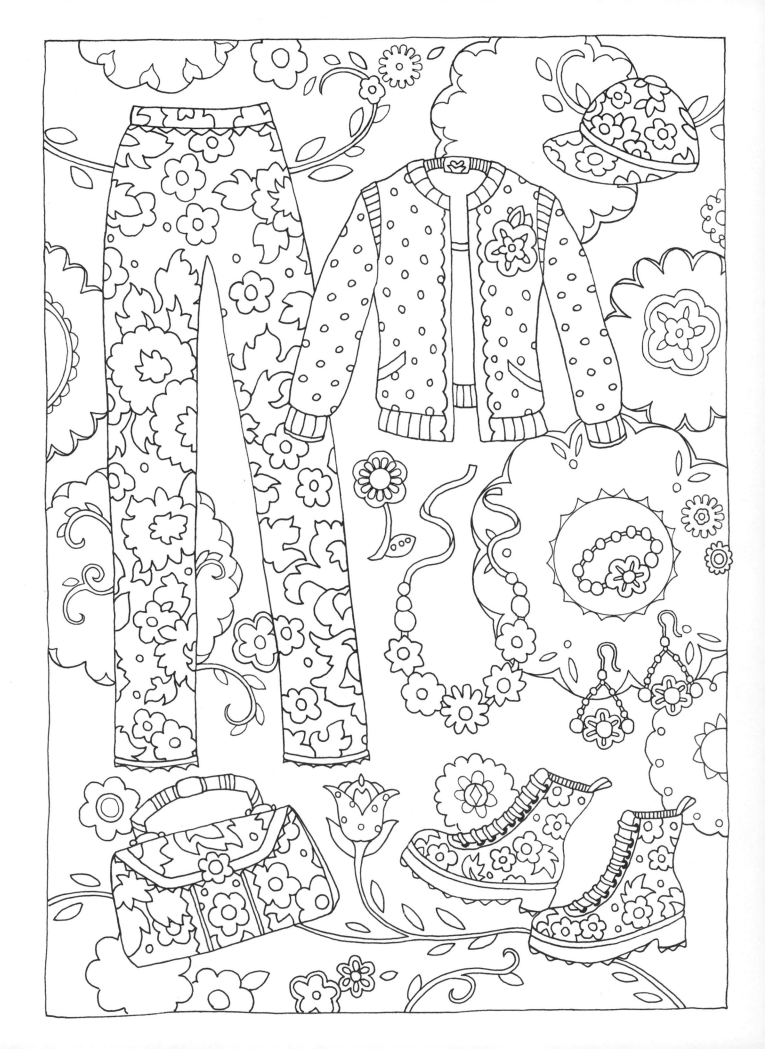

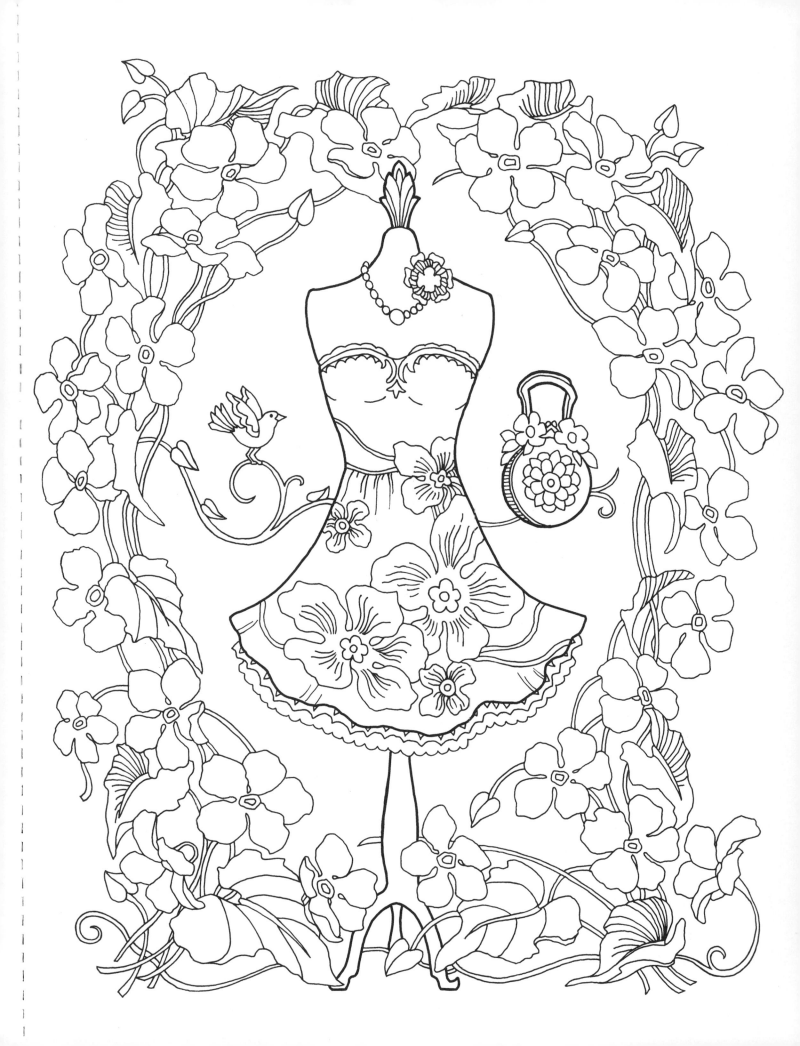

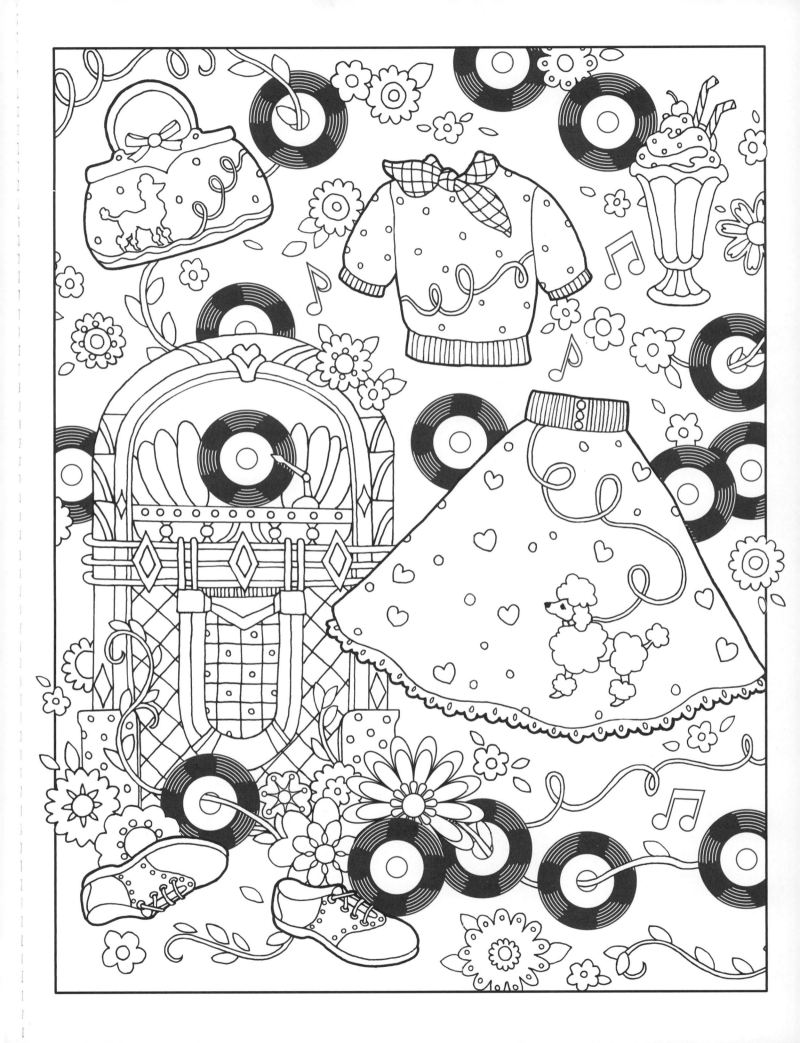

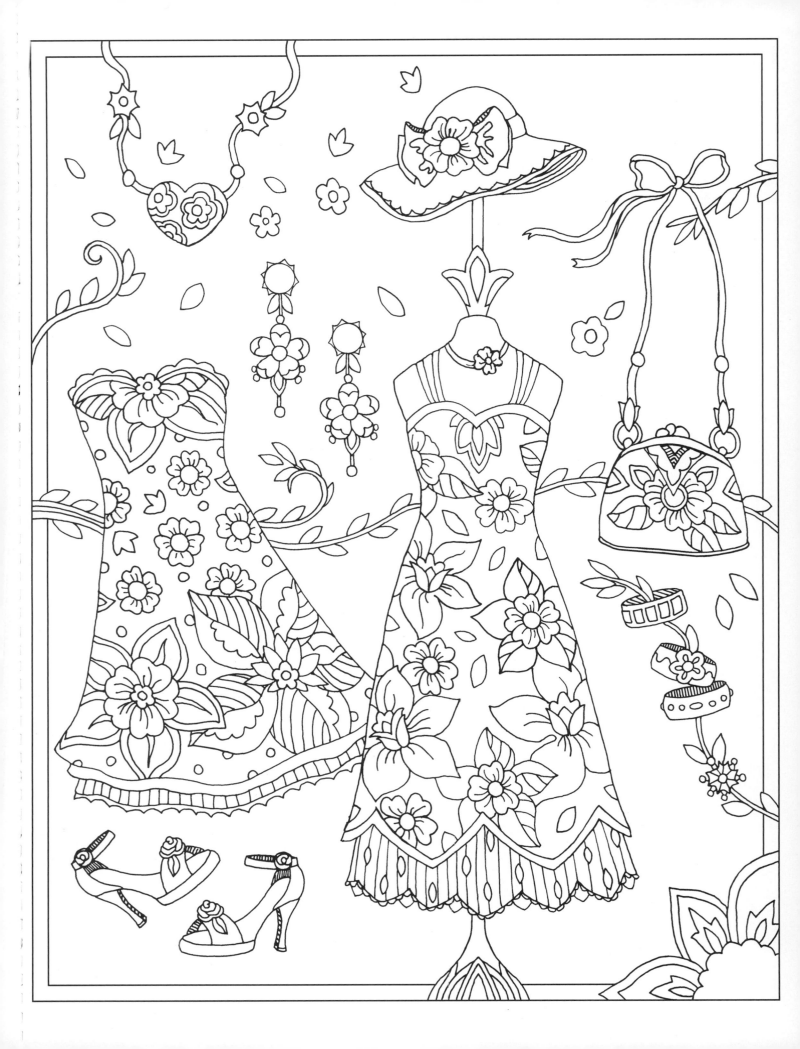

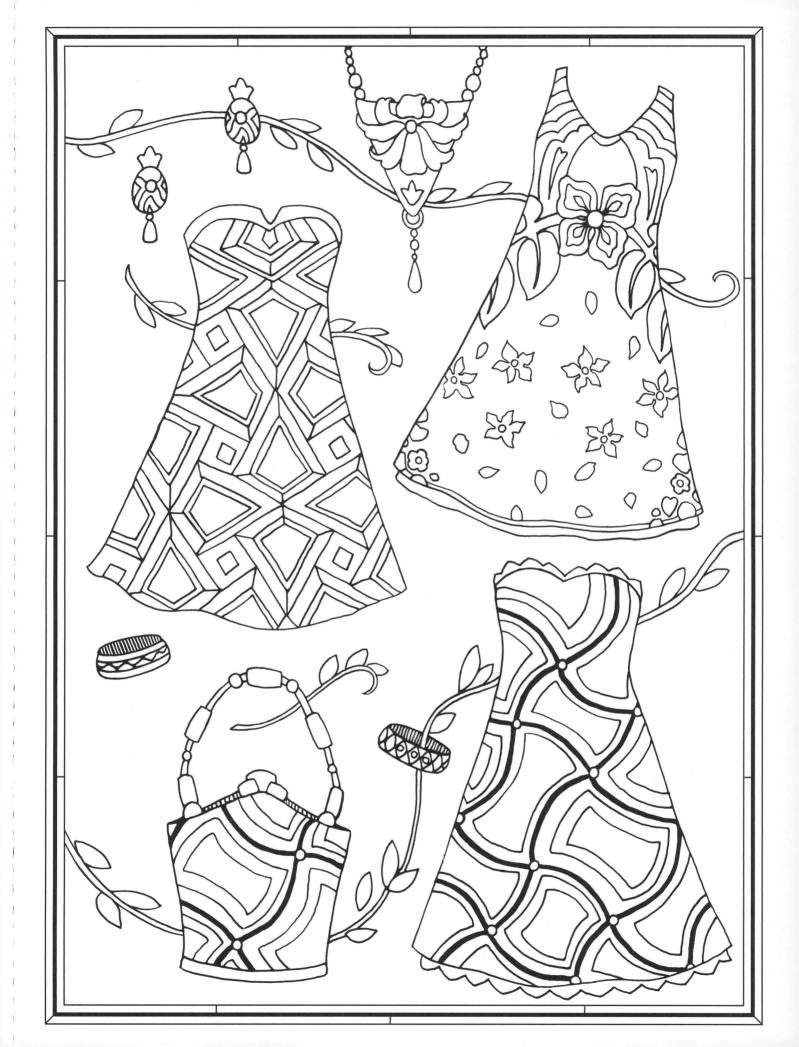

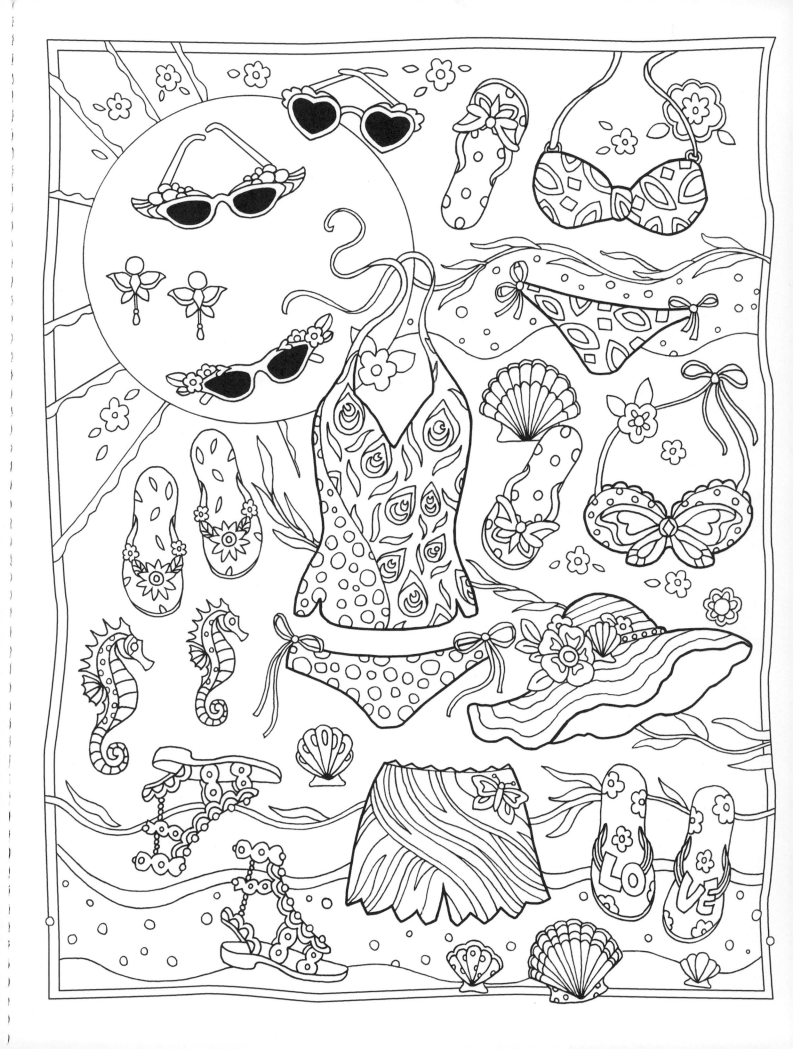

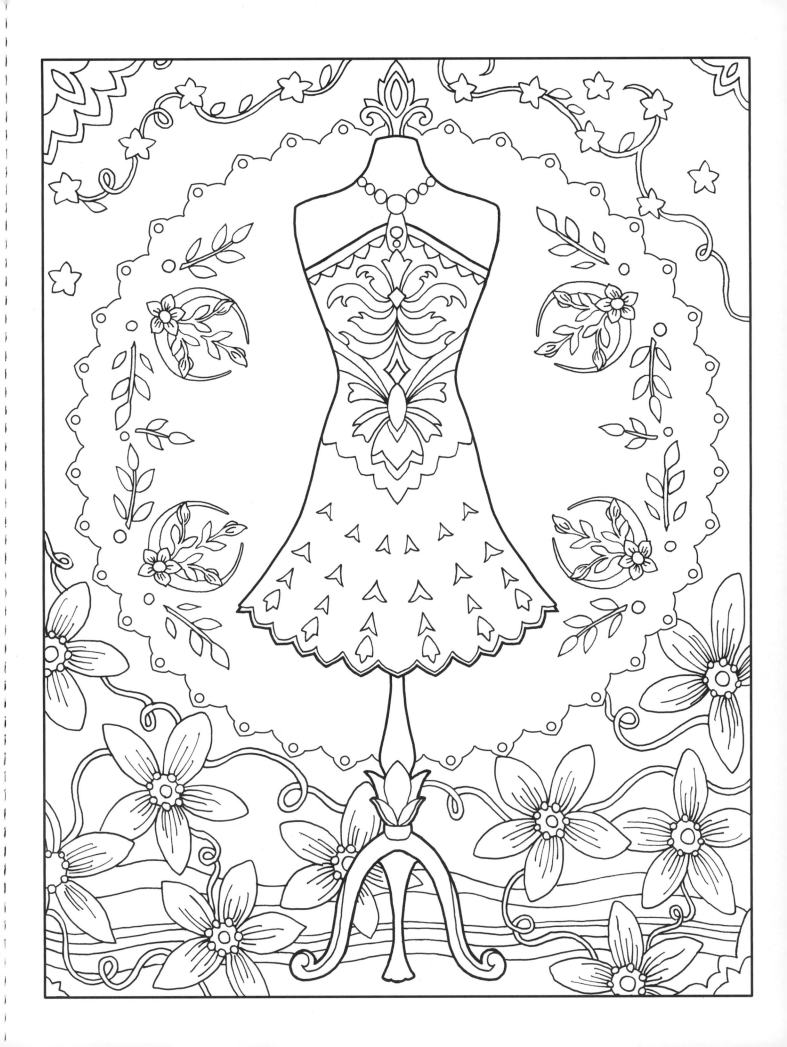

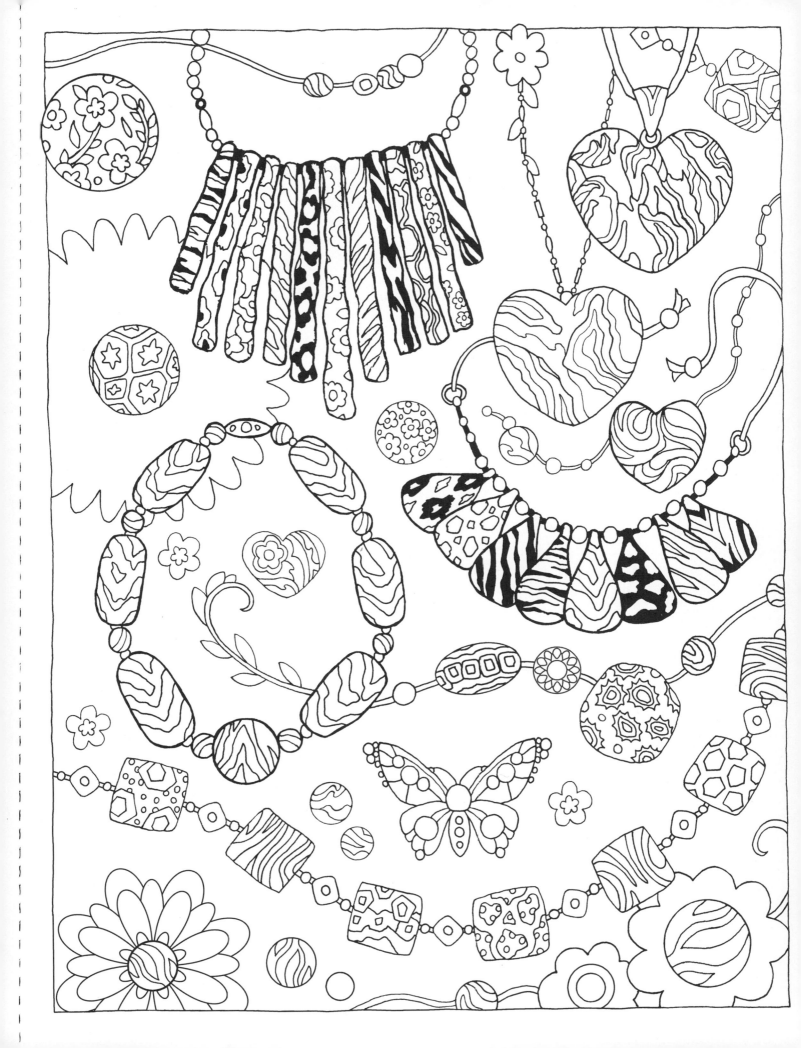

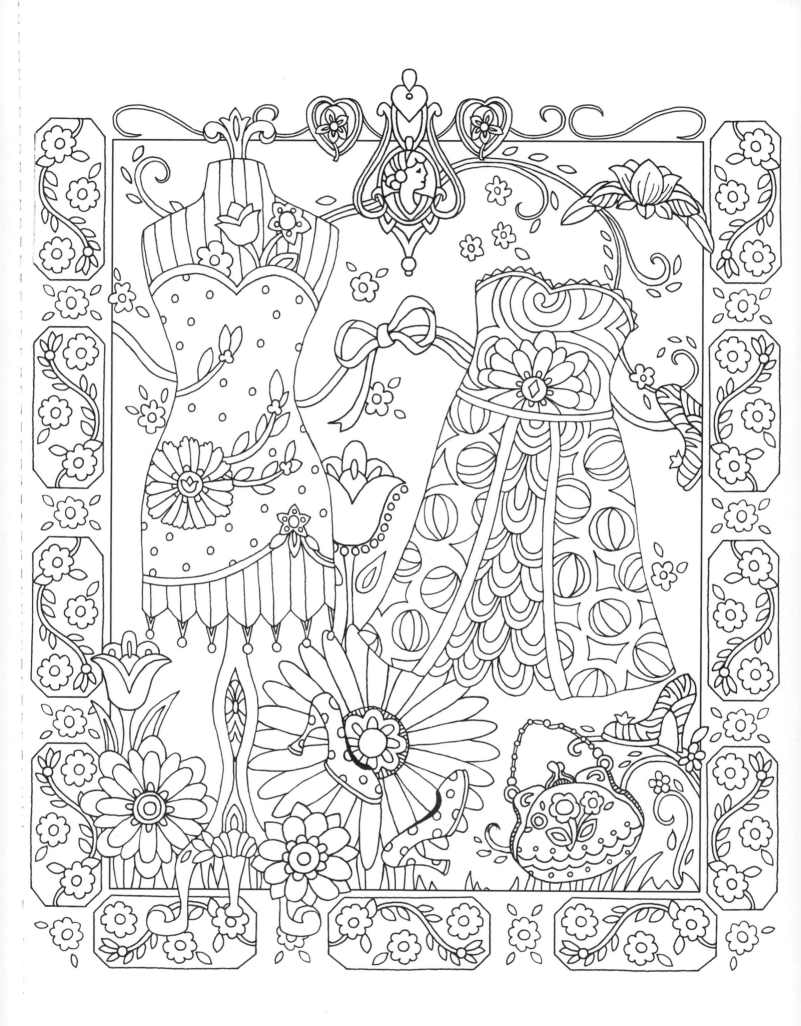

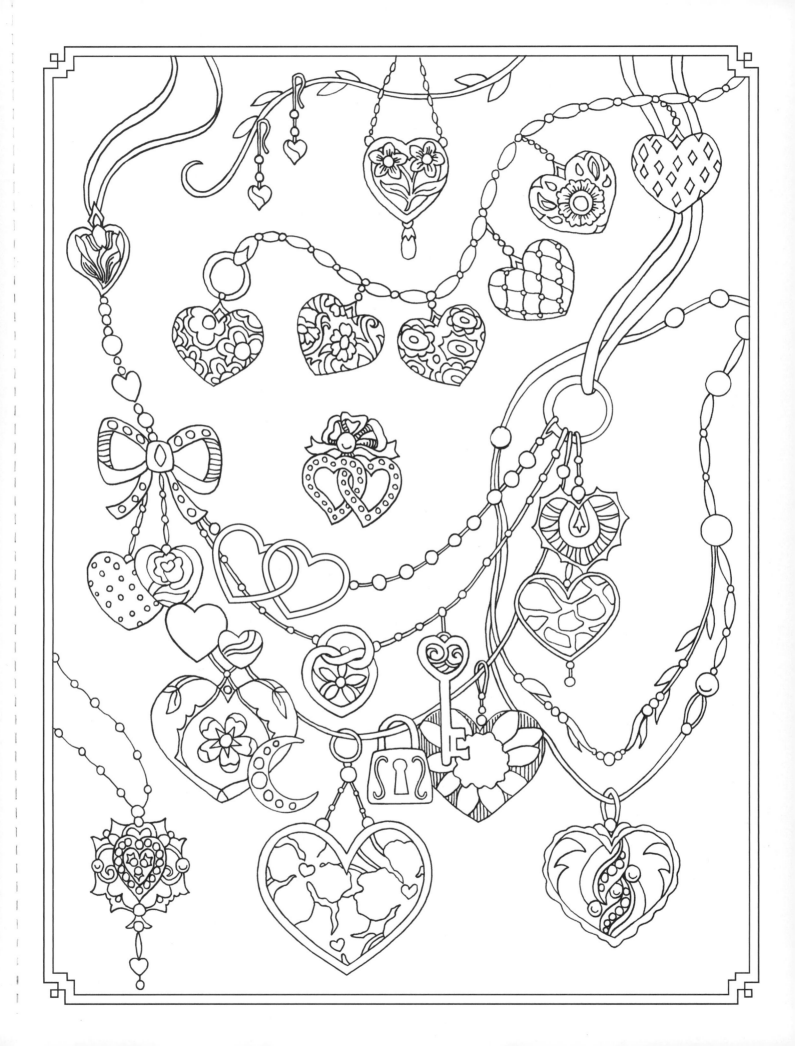

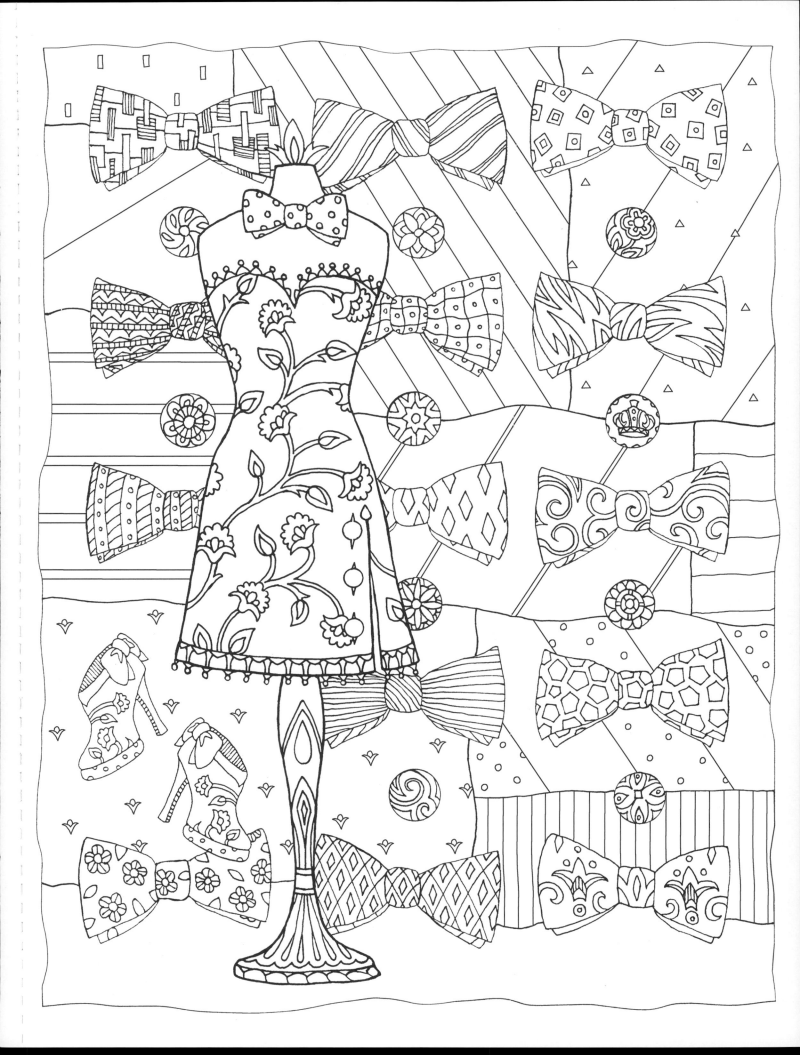

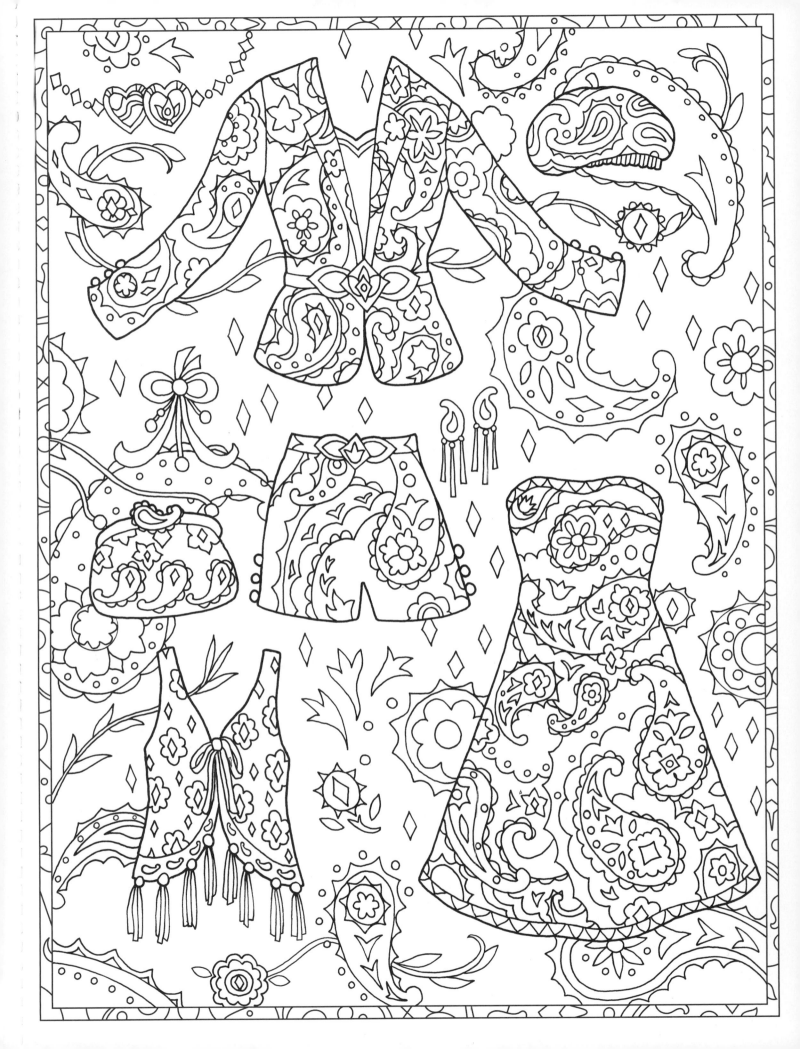

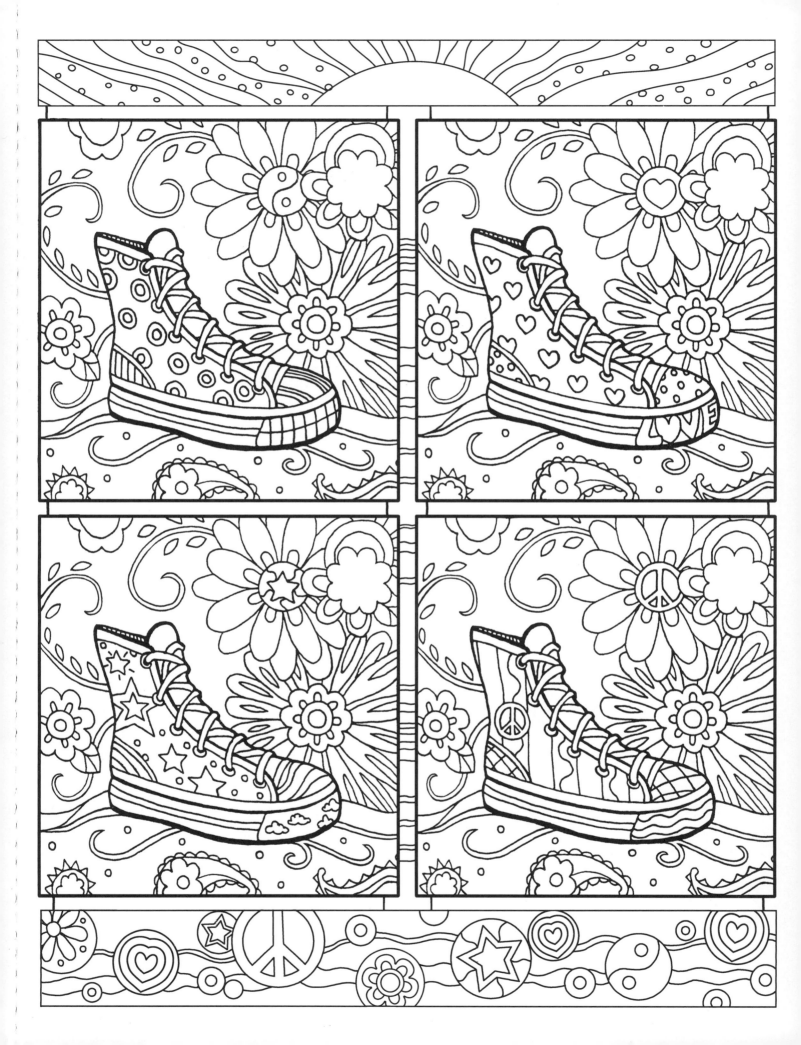

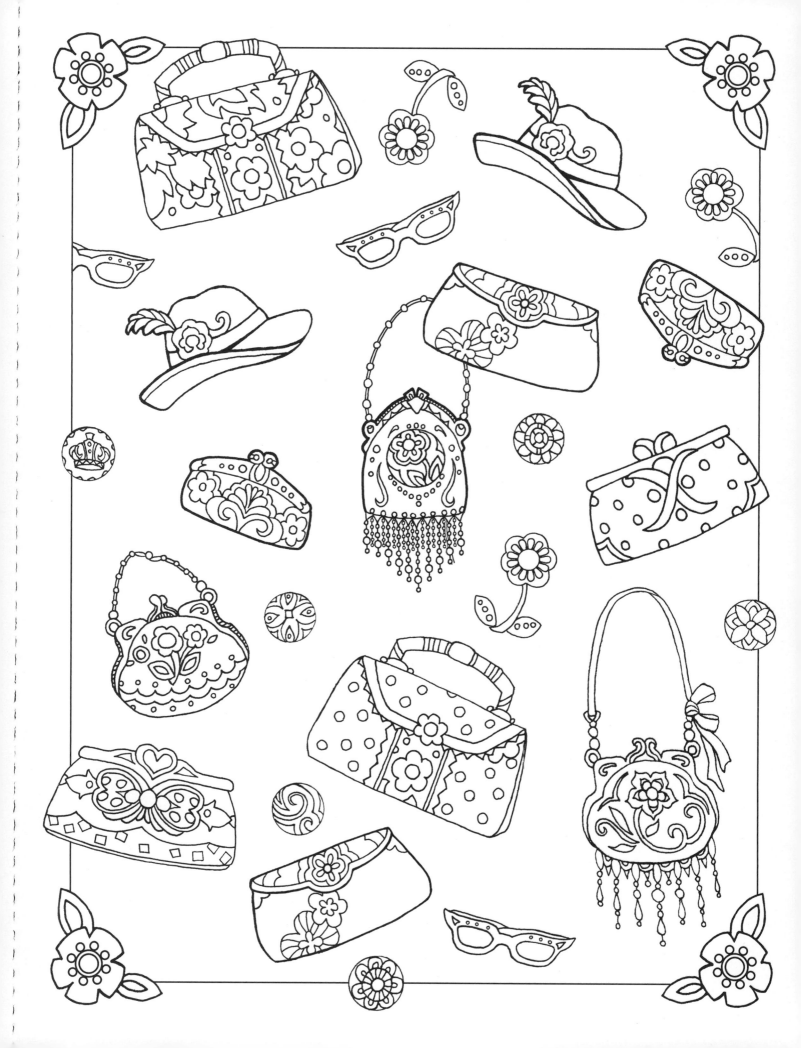

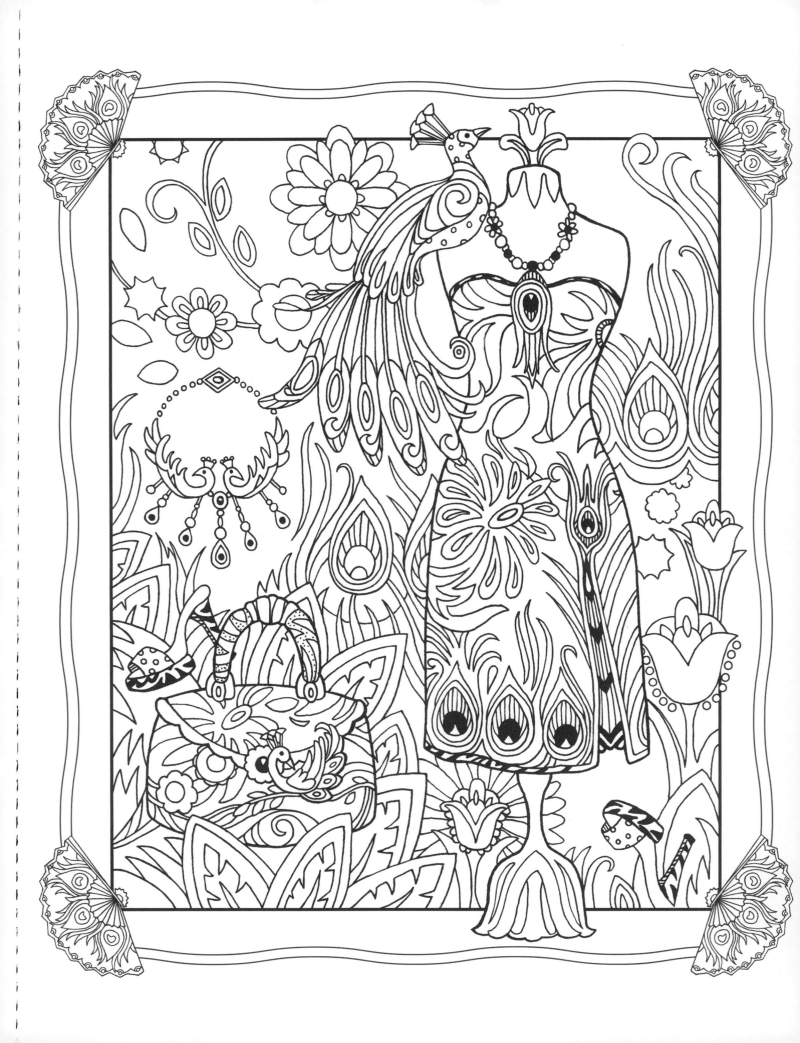

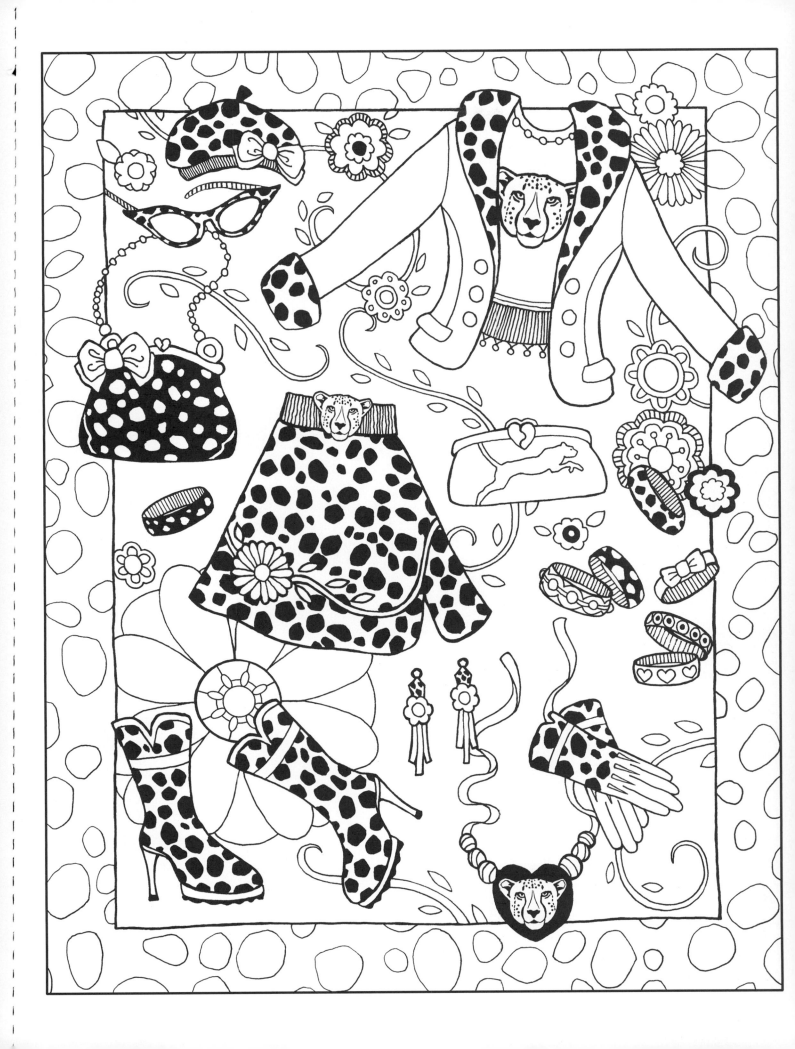

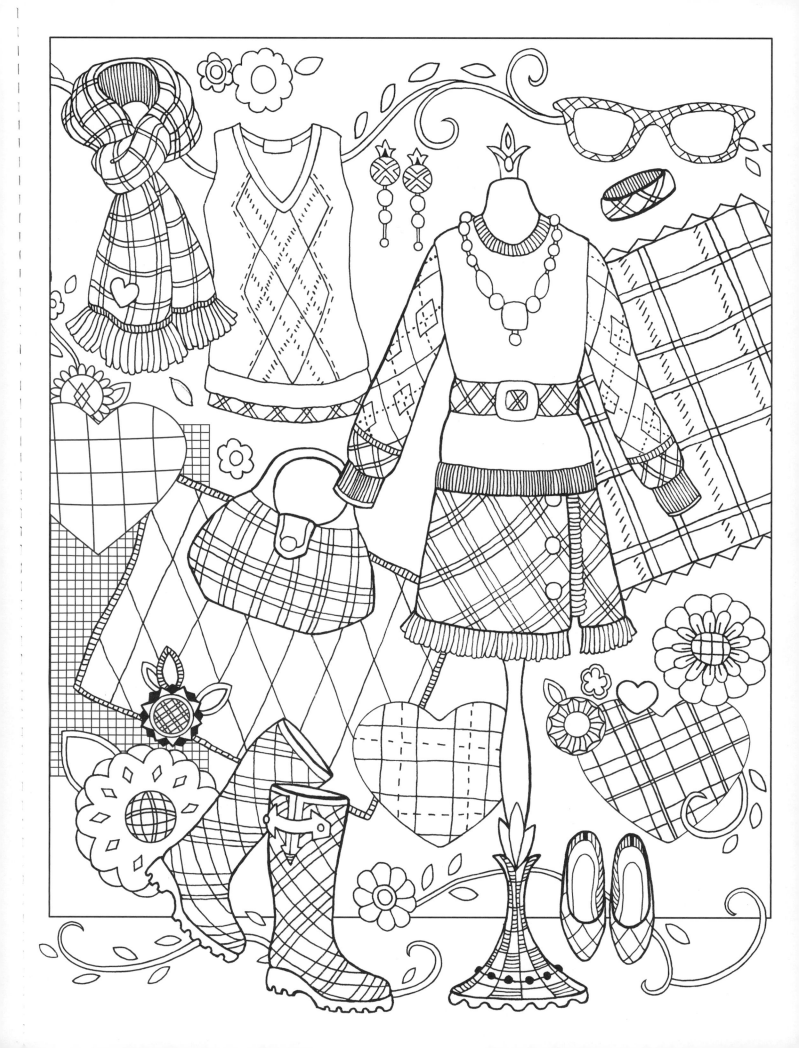

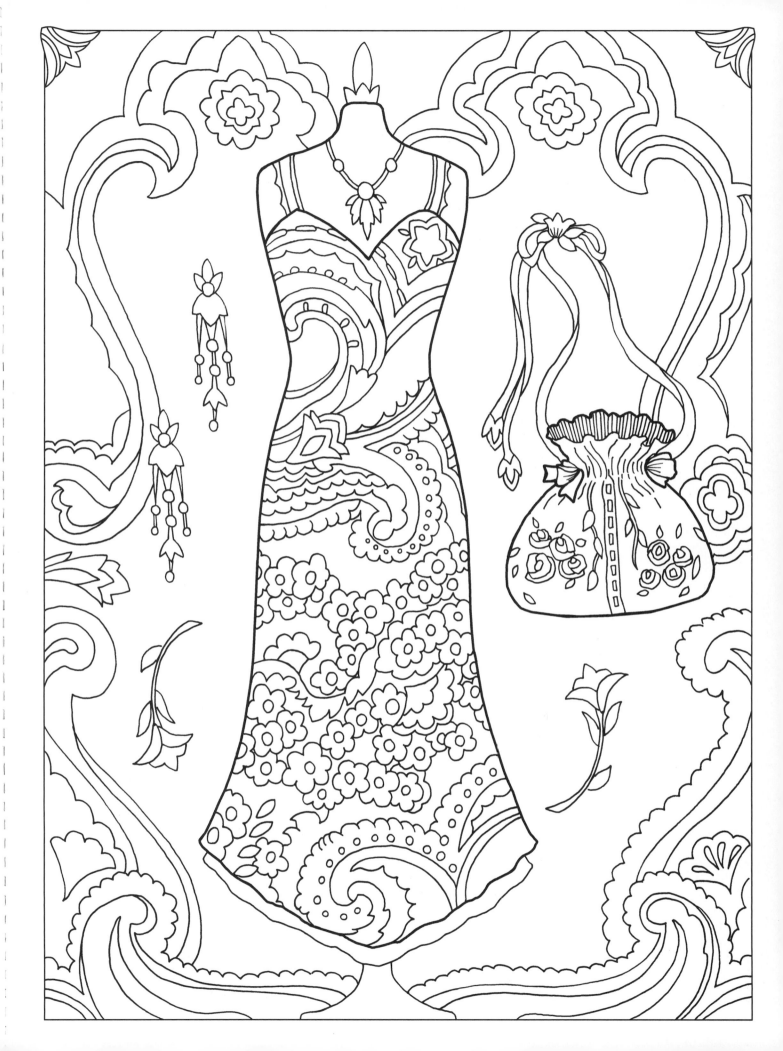

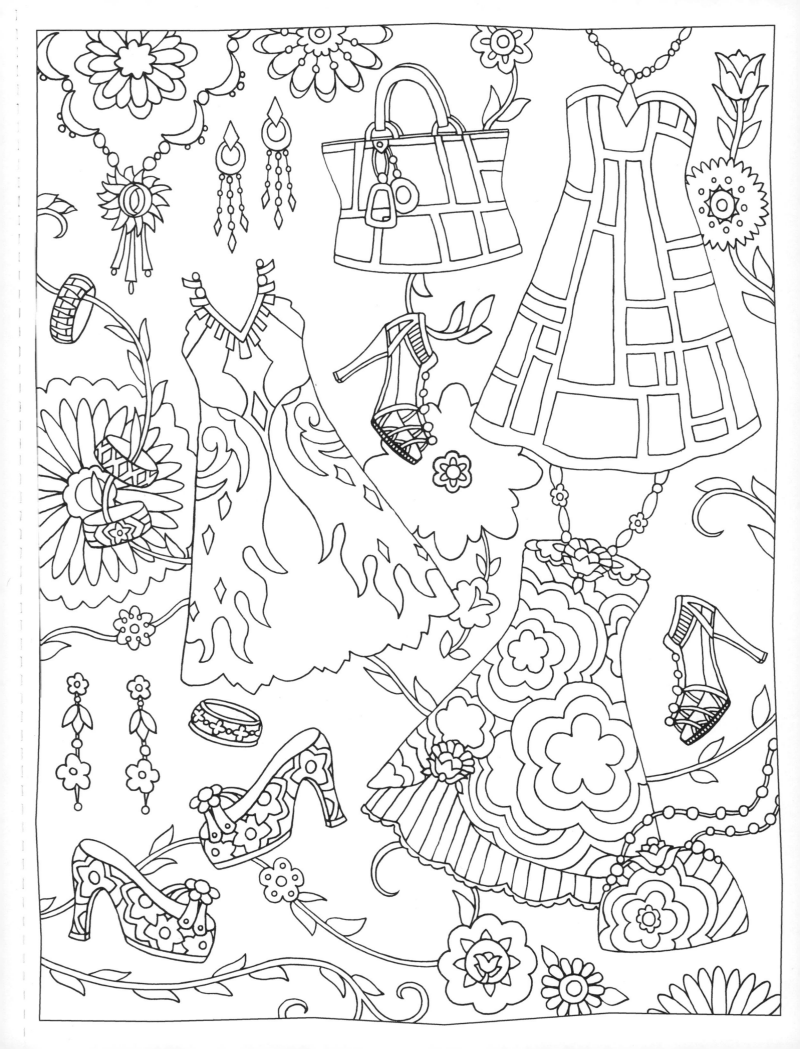

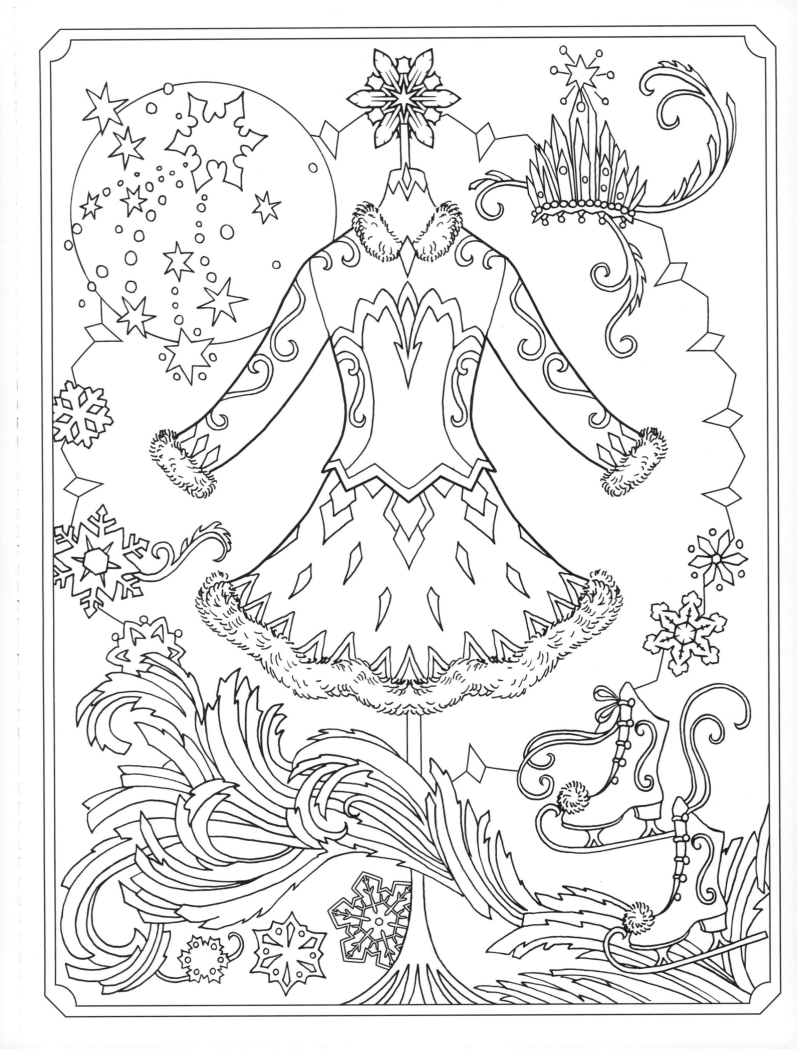

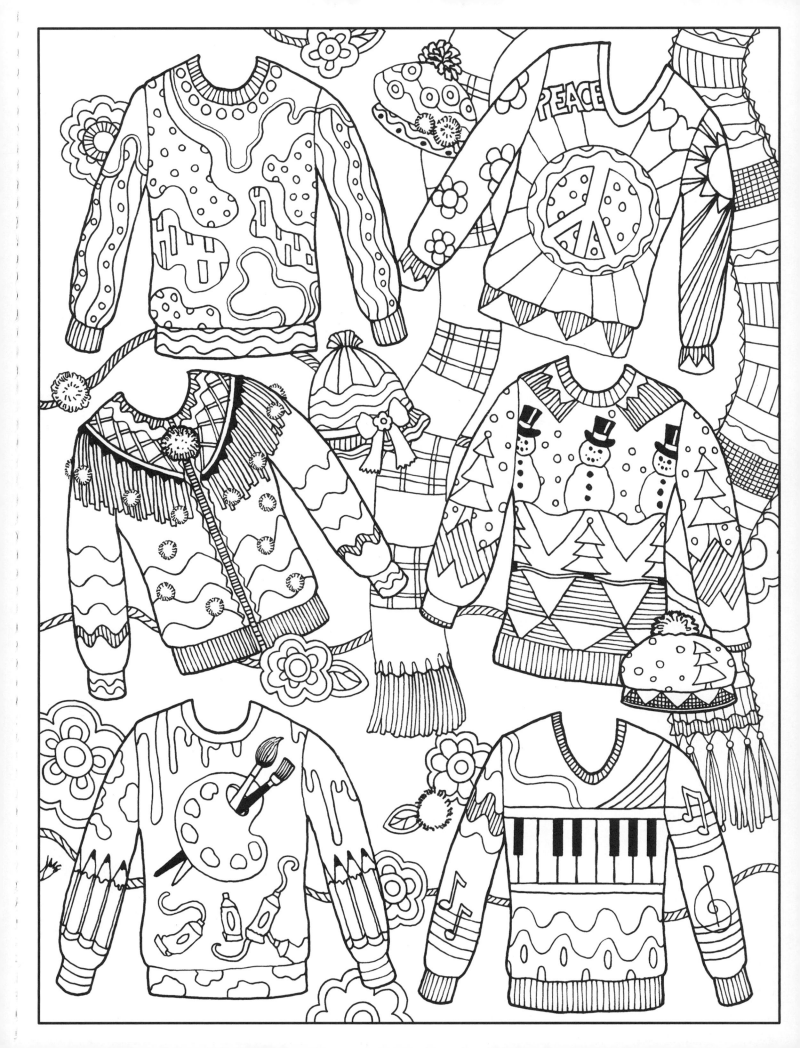

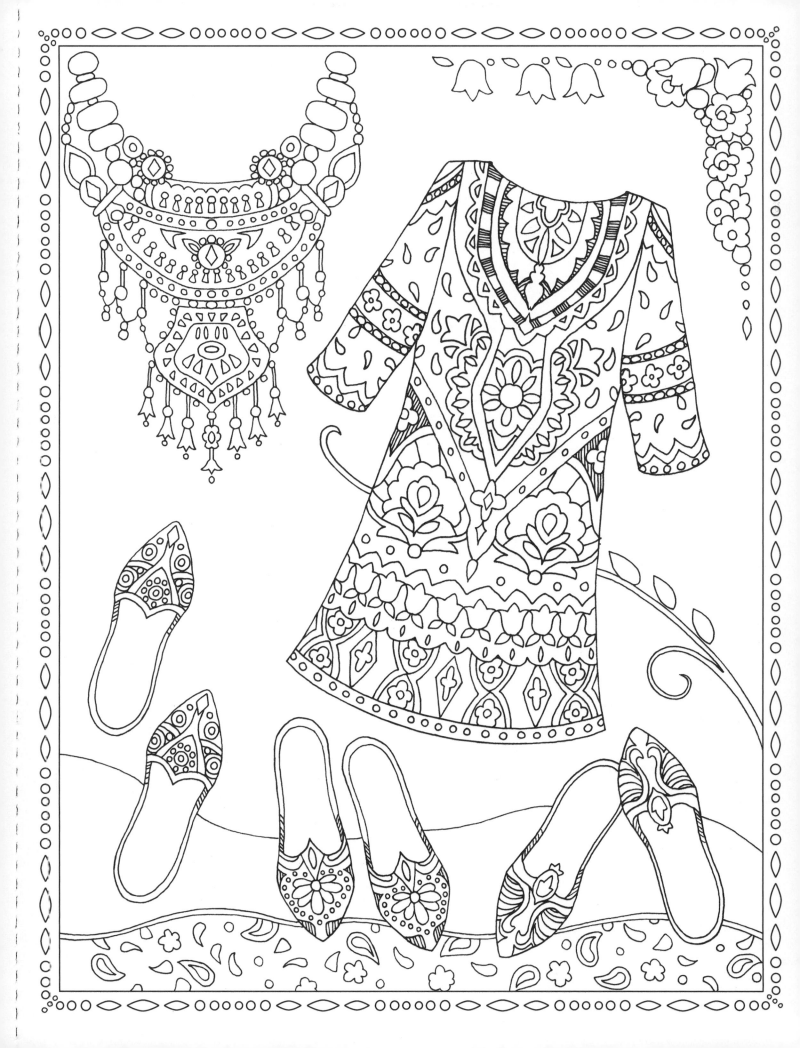

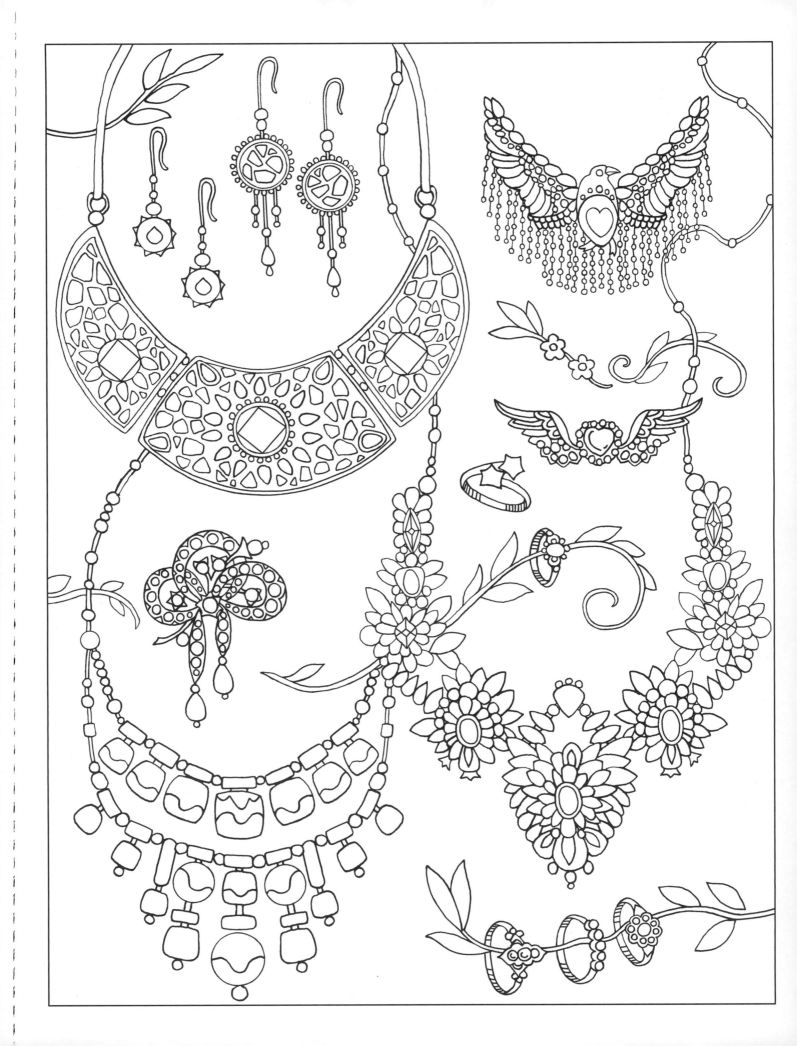

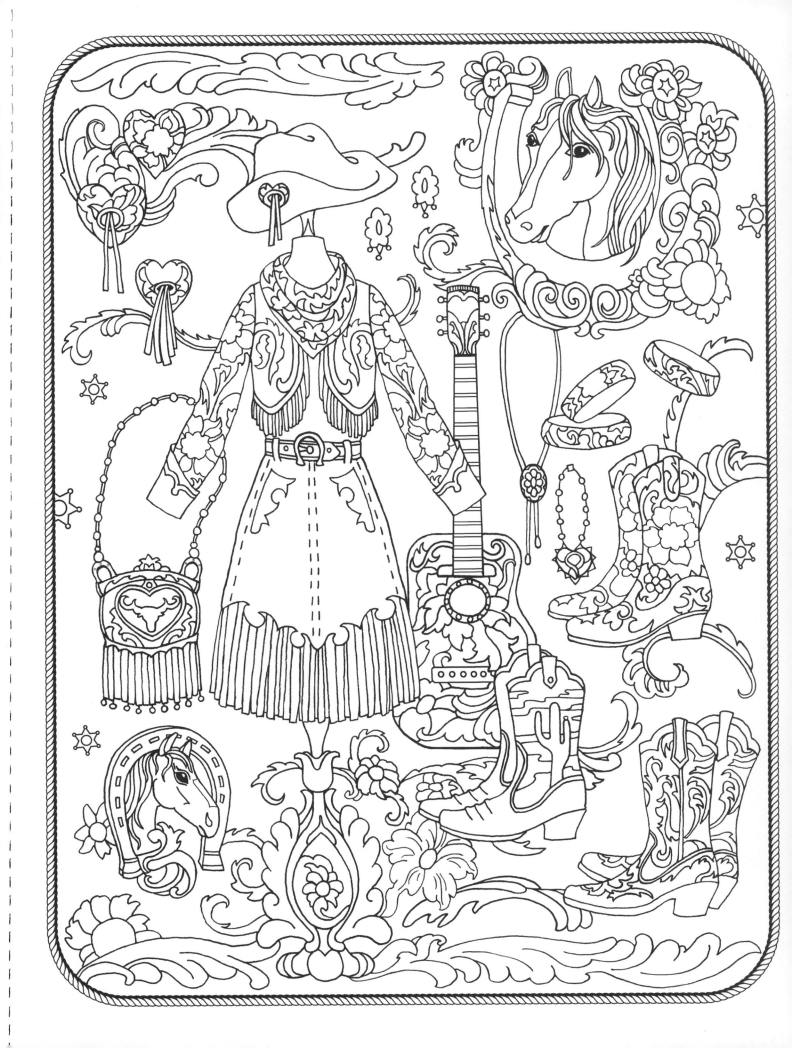

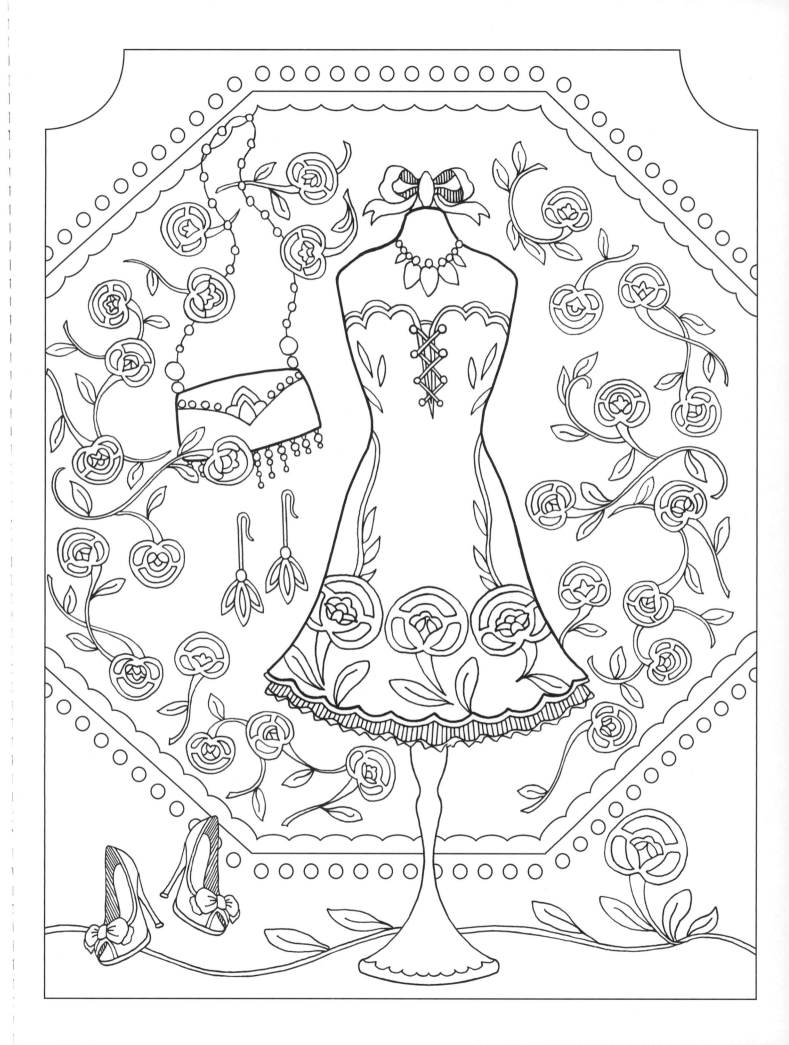

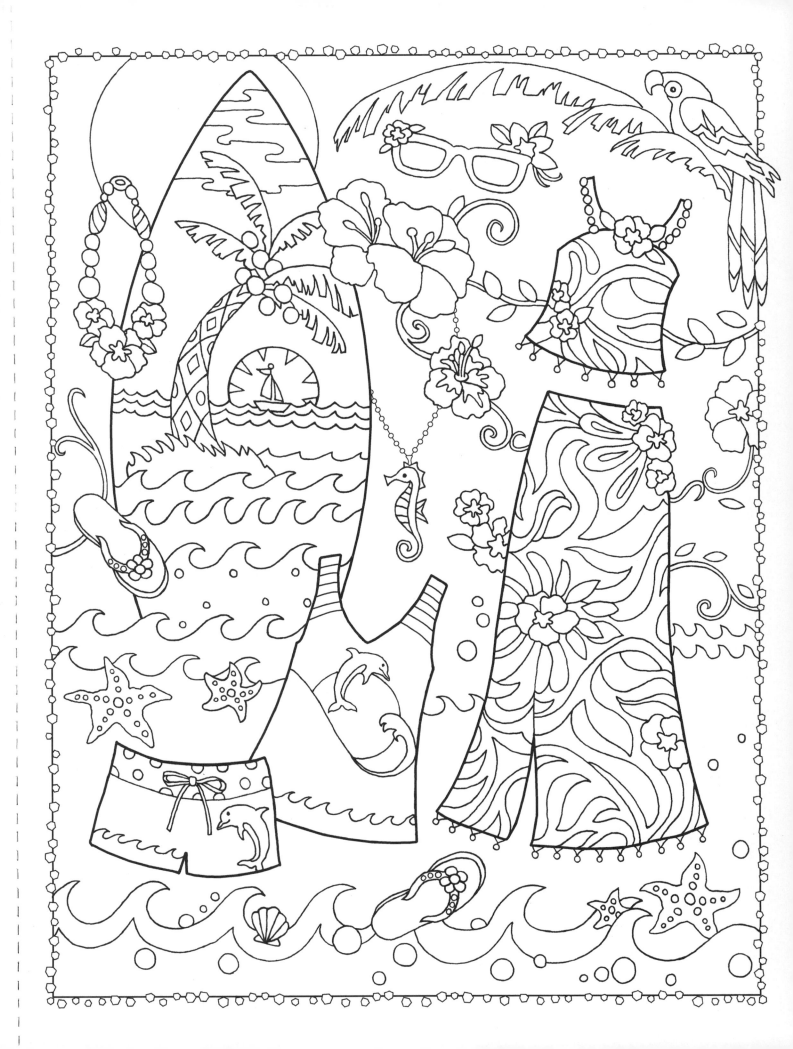

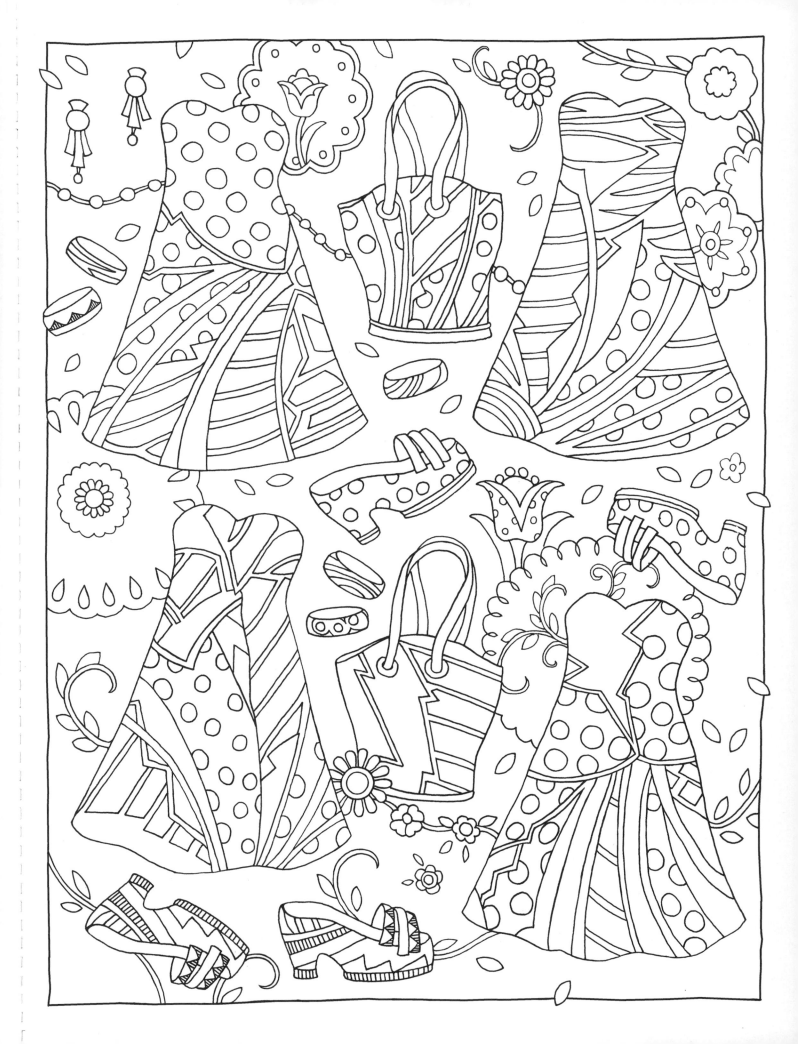

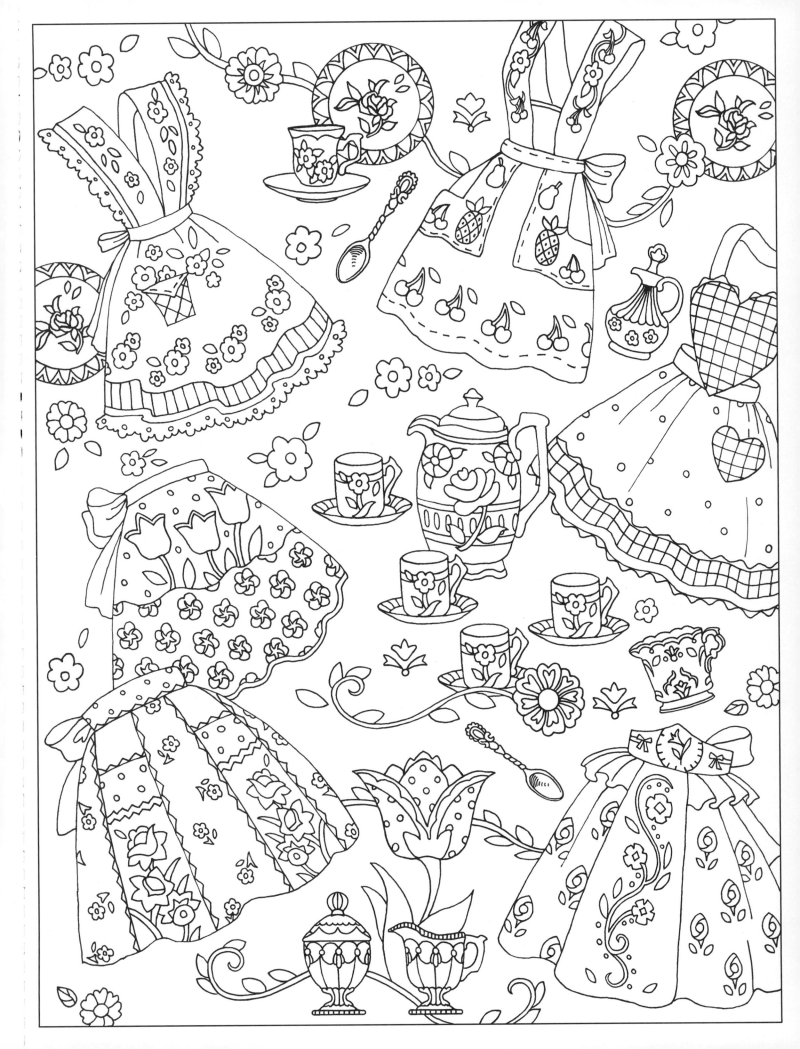

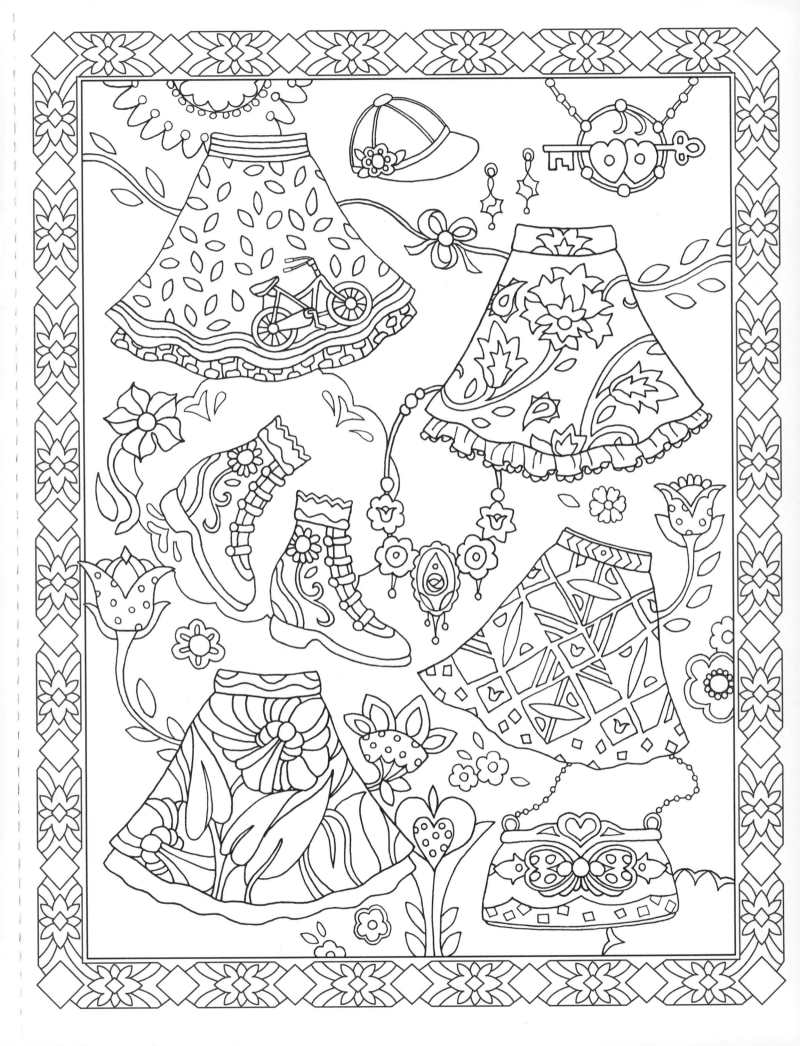

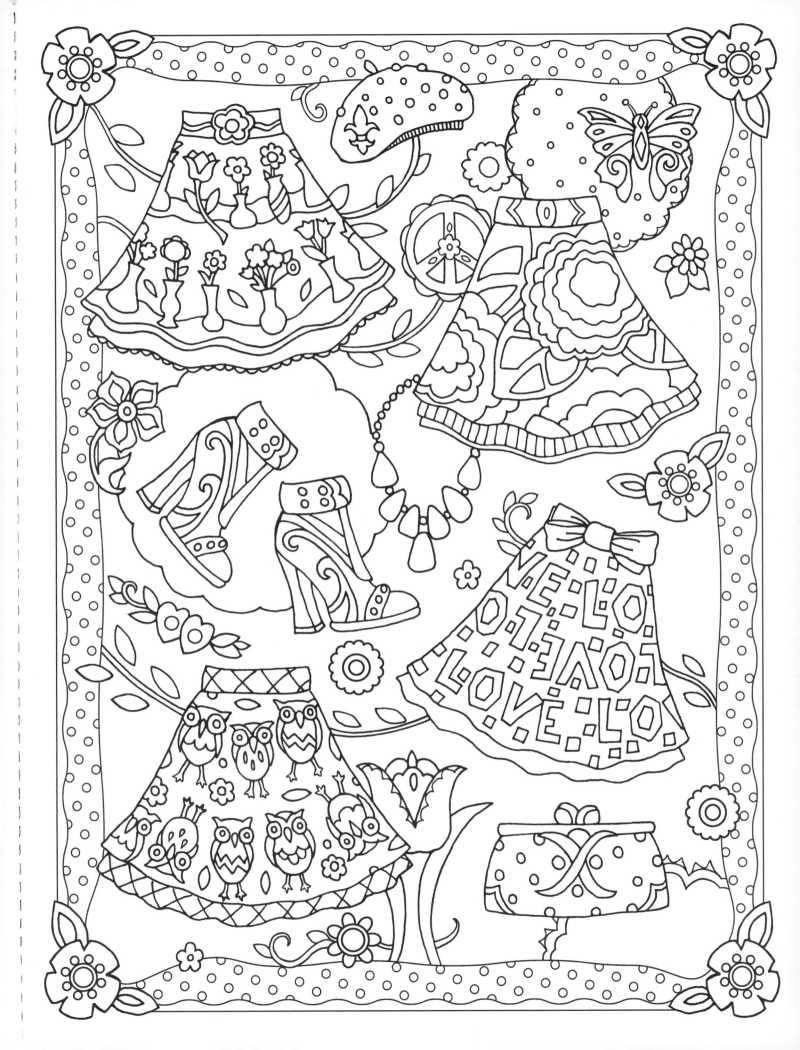

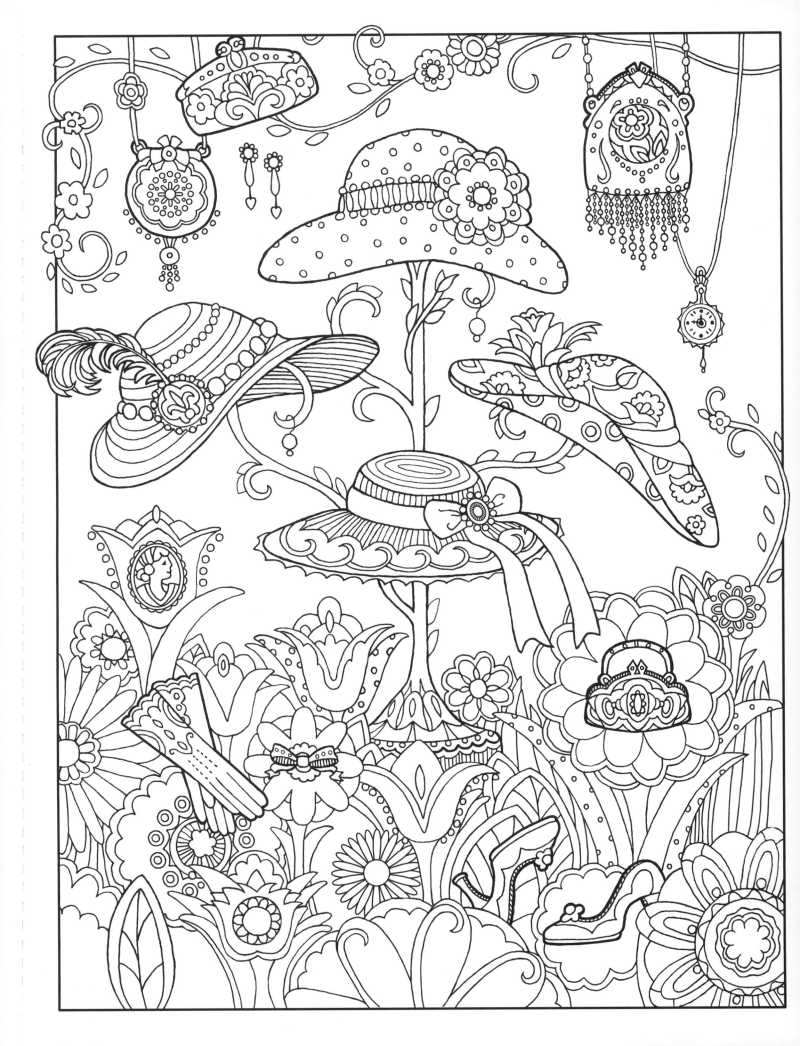

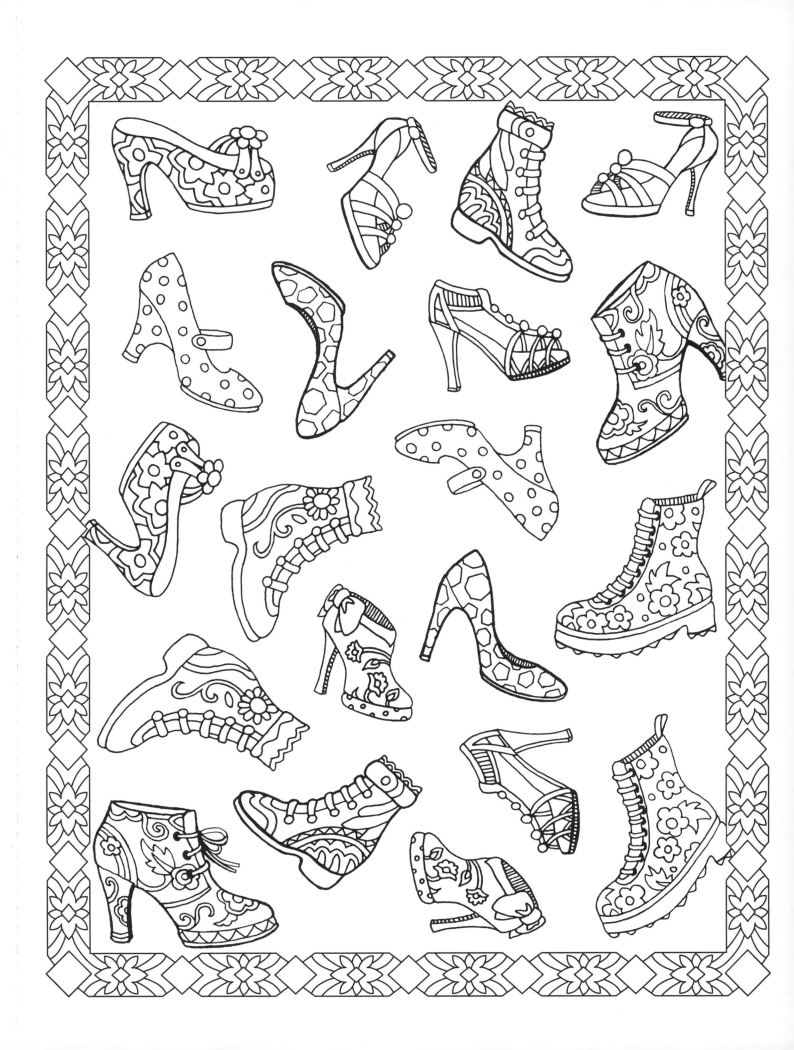

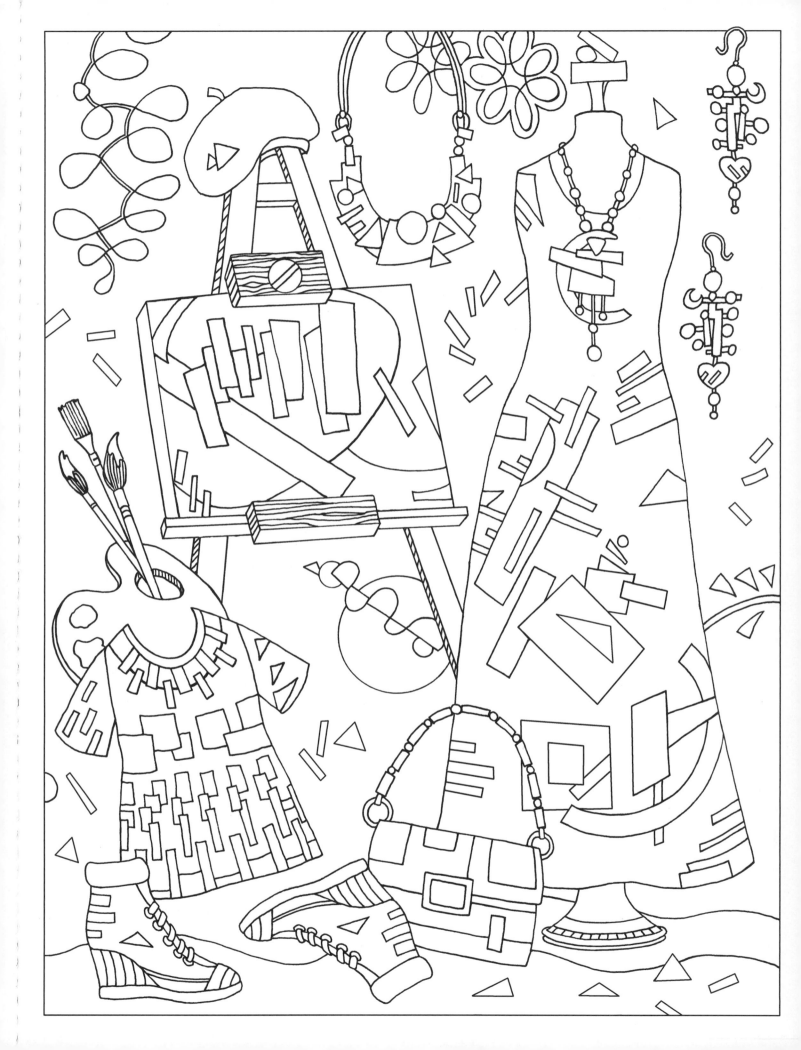

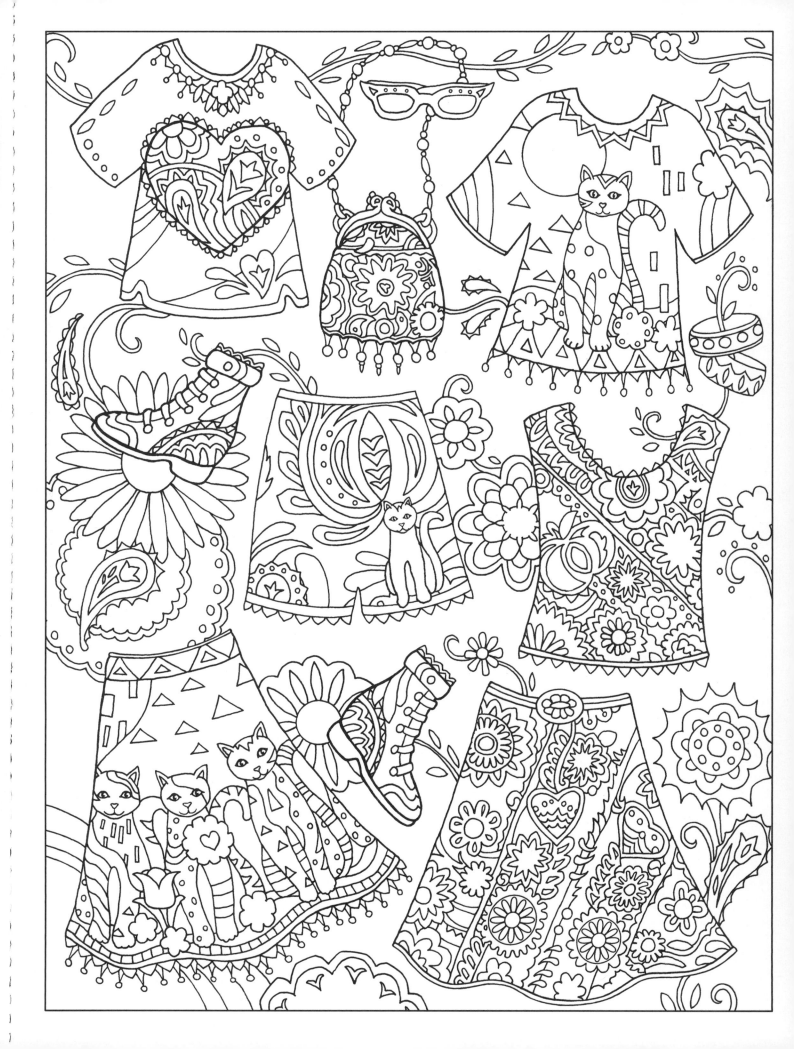

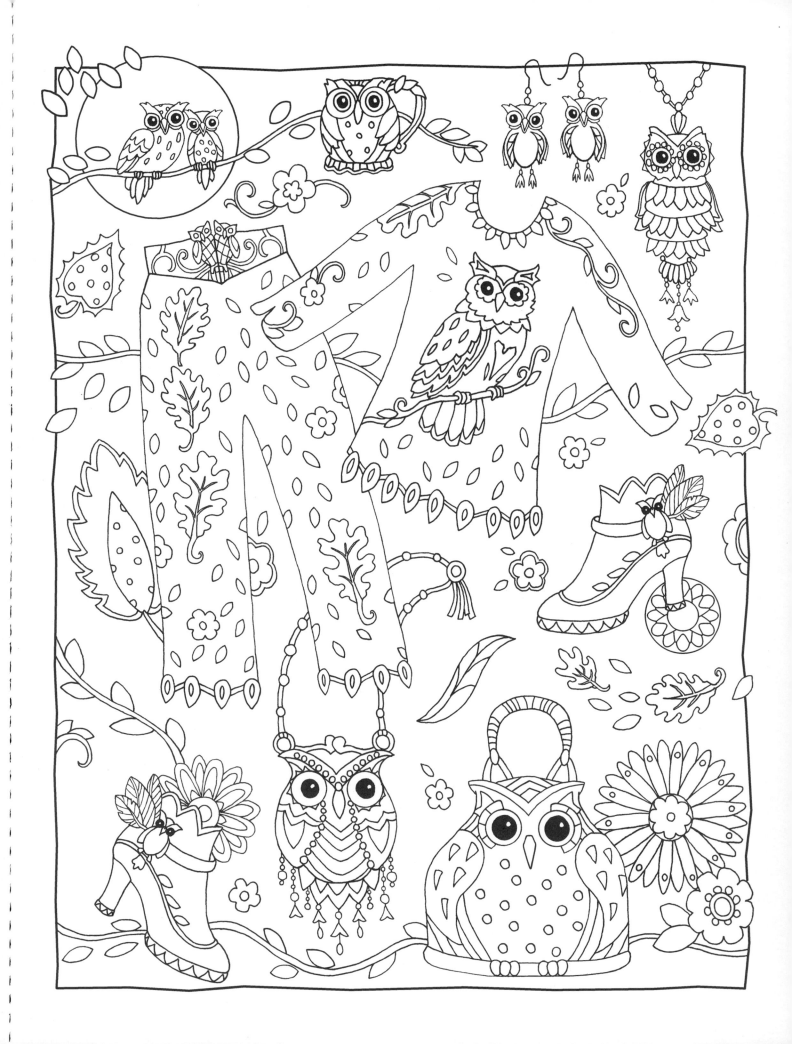

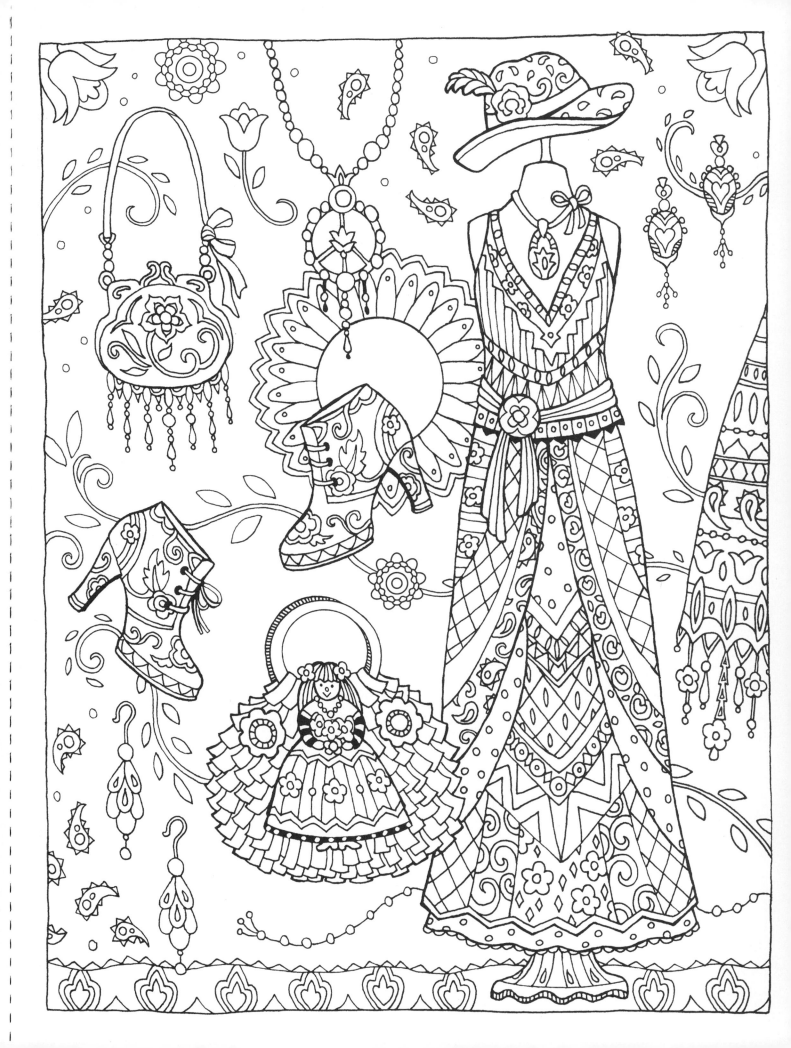

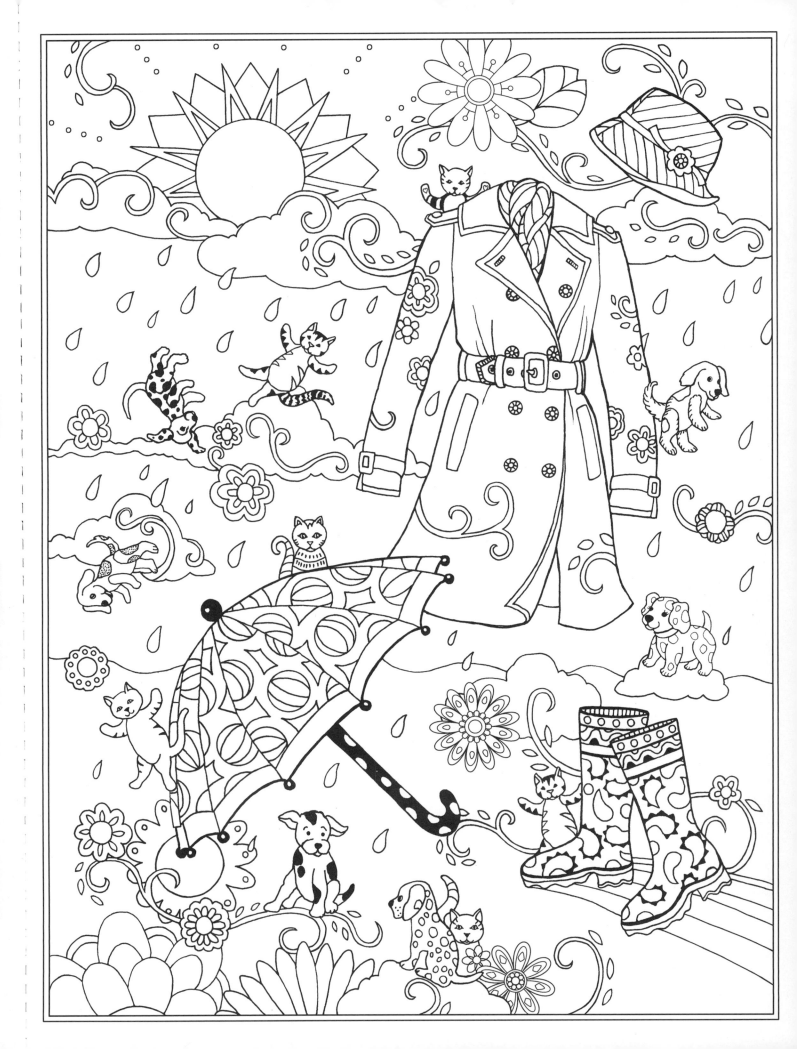

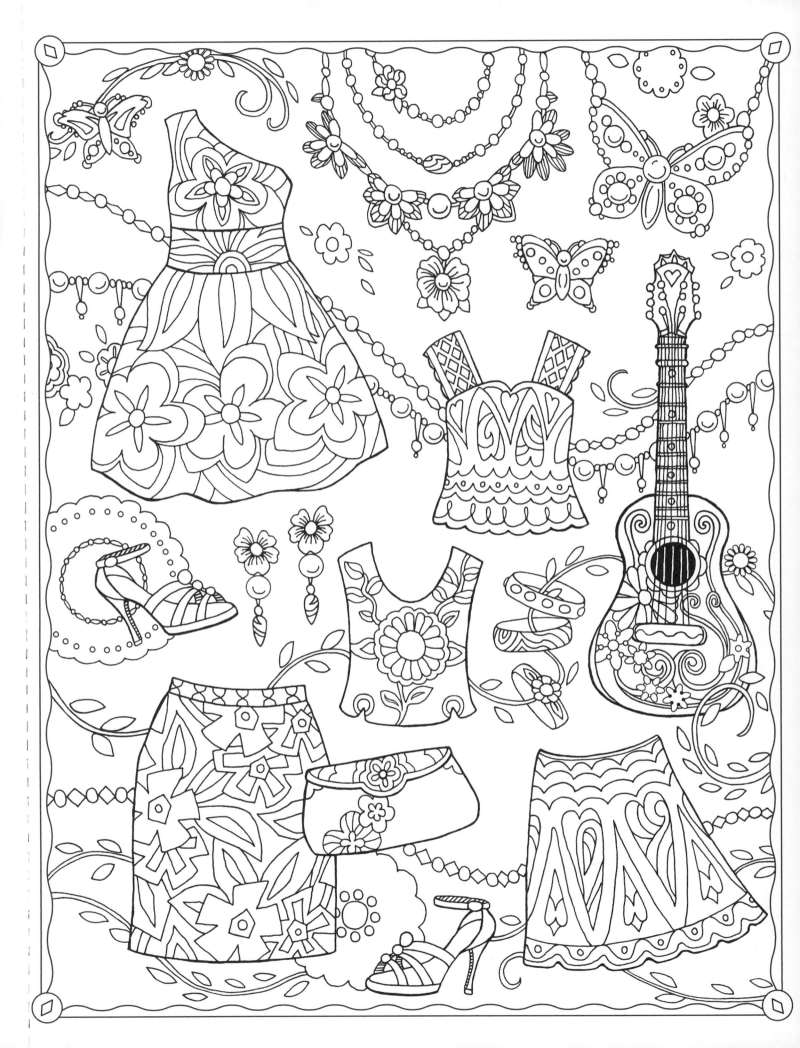

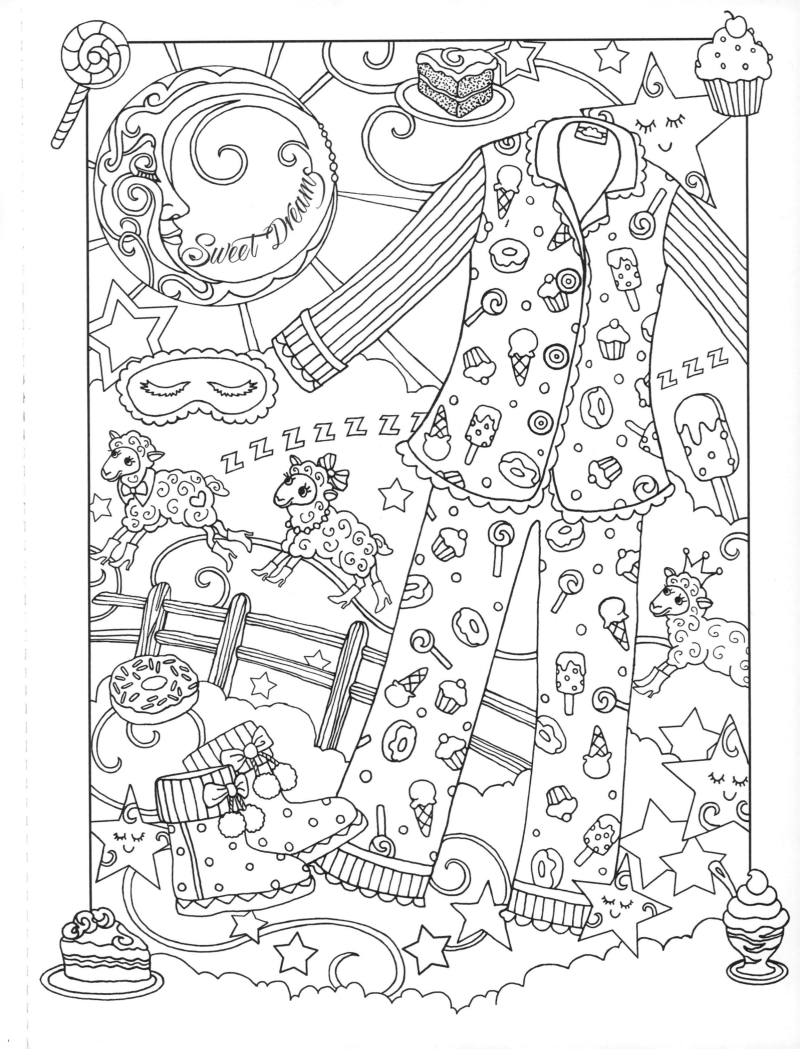

Fashion, as one of the most accessible means of artistic self expression, has given us mementos from each passing generation—from flapper dresses in the twenties, to bell bottoms in the seventies, to backwards caps in the nineties, these trends will be forever associated with the generation who brought them to life, and their story. Think flower patterns and the sixties.

Whether it's through magazines, ads on television, our jobs, our relationships, or some other medium, fashion plays a huge role in our daily lives and our ability to express ourselves. By combining various clothing and accessories, you're able to create your own unique style that, in a way, displays a small part of who you are. Choosing dresses, coats, hats, bags, watches, necklaces, or shoes to compose outfits can be a great way to have fun and relax, while simultaneously showing people another facet of your personality.

Like fashion, adult coloring can be an excellent outlet for relaxing, relieving stress, having fun, and expressing yourself. However, it is not so often that you get to color and decorate your own clothes. This adult coloring book takes you on a journey into the world of fashion and how creative it can be. Featuring outlines of jeans, dresses, sweaters, and tons more for you to color, *Marjorie Sarnat's Fanciful Fashions* is the perfect way to transform your wardrobe—and have fun doing it.

cx

Marjorie Sarnat is a *New York Times* bestselling author and illustrator of several coloring books and more than a dozen books on art and creativity. She is also an award-winning mixed-media artist whose works are in collections worldwide. Born and raised in Chicago, Marjorie is an alumna of the School of the Art Institute of Chicago and earned a BFA degree from Eastern Michigan University. Marjorie's fanciful coloring book style evolved from her love of patterns, which she developed through an earlier career as a textile designer. Also influencing her style is her lifelong passion for collecting vintage illustrated books and ephemera. She lives in Granada Hills, California, with her husband, daughter, and son, her two dogs, and her extensive antique book collection.

Also Available from Skyhorse Publishing

Creative Stress Relieving Adult Coloring Book Series
Art Nouveau: Coloring for Artists
Art Nouveau: Coloring for Everyone
Curious Cats and Kittens: Coloring for Artists
Curious Cats and Kittens: Coloring for Everyone
Mandalas: Coloring for Artists
Mandalas: Coloring for Everyone
Mehndi: Coloring for Artists
Mehndi: Coloring for Everyone
Nirvana: Coloring for Artists
Nirvana: Coloring for Everyone
Paisleys: Coloring for Artists
Paisleys: Coloring for Everyone
Tapestries, Fabrics, and Quilts: Coloring for Artists
Tapestries, Fabrics, and Quilts: Coloring for Everyone
Whimsical Designs: Coloring for Artists
Whimsical Designs: Coloring for Everyone
Whimsical Woodland Creatures: Coloring for Everyone
Zen Patterns and Designs: Coloring for Artists
Zen Patterns and Designs: Coloring for Everyone

***New York Times* Bestselling Artist's Adult Coloring Book Series**
Marty Noble's Sugar Skulls: New York Times *Bestselling Artists' Adult Coloring Books*
Marty Noble's Peaceful World: New York Times *Bestselling Artists' Adult Coloring Books*

The Peaceful Adult Coloring Book Series
Adult Coloring Book: Be Inspired
Adult Coloring Book: De-Stress
Adult Coloring Book: Keep Calm
Adult Coloring Book: Relax

Portable Coloring for Creative Adults
Calming Patterns: Portable Coloring for Creative Adults
Flying Wonders: Portable Coloring for Creative Adults
Natural Wonders: Portable Coloring for Creative Adults
Sea Life: Portable Coloring for Creative Adults